IMAGES
of America

NEWPORT BEACH'S
BALBOA AND
BALBOA ISLAND

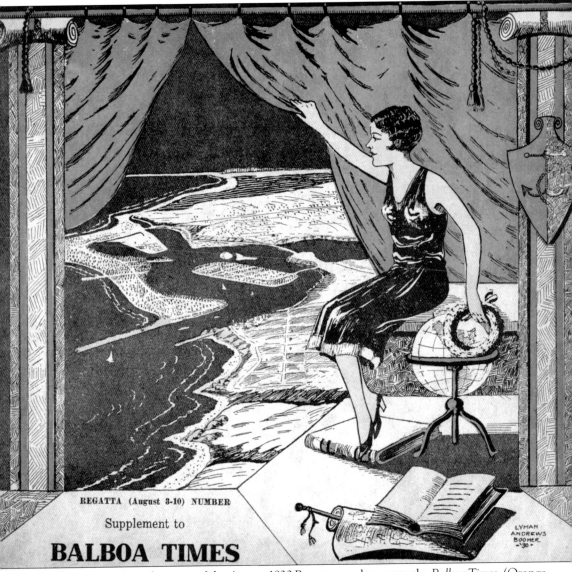

REGATTA (August 3-10) NUMBER

Supplement to

BALBOA TIMES

LYMAN
ANDREWS
BOOMER
-'30-

This image is from the cover of the August 1930 Regatta supplement to the *Balboa Times*. (Orange County Archives.)

ON THE COVER: In the 1920s, a group of bathers is pictured on the beach at Balboa east of the pier. Visitors would come down on the Pacific Electric Red Car in street clothes, then rent bathing togs for the day at the Ocean Front Bath House, located west of the pier. (Delaney collection.)

IMAGES
of America

NEWPORT BEACH'S BALBOA AND BALBOA ISLAND

Jeff Delaney

ARCADIA
PUBLISHING

Published by Arcadia Publishing
Charleston SC, Chicago IL, Portsmouth NH, San Francisco CA

Printed in the United States of America

Library of Congress Catalog Card Number: 2007930846

For all general information contact Arcadia Publishing at:
Telephone 843-853-2070
Fax 843-853-0044
E-mail sales@arcadiapublishing.com
For customer service and orders:
Toll-Free 1-888-313-2665

Visit us on the Internet at www.arcadiapublishing.com

This book is dedicated to William Larkin Delaney, 19.75 inches long and weighing in at 6 pounds, 14 ounces; and his beautiful mother, who spent 50 days and nights in the hospital to bring him safely into the world.

CONTENTS

ACKNOWLEDGMENTS

I would like to thank the following individuals and organizations for their generous contribution of photographs, historical knowledge, and support during the writing of this book: Bob Blankman and the First American Corporation; Melissa Lew and the Newport Harbor Nautical Museum; Phil Brigandi and the Orange County Archives; Craig Page and the Balboa Island Historical Society; David and Barbara Rucker; Christopher Trela; Gay Wassall-Kelly; and John Vale.

INTRODUCTION

Let's not beat around the bush; Balboa was "Sin City."

Pretty pictures and postcards of Balboa's early days show crowds arriving at the beach and bay to relax on the sand, walk the pier, take canoe rides, and perhaps, partake of a Balboa bar on a hot, summer day. As pleasing as those images may be, they lack one essential component, truth. People didn't come here to convalesce, to recline, or to stroll. People came to Balboa to party. And party they did.

And it's lucky that they did. When the Depression hit in 1929, many small towns across America simply vanished off the map. With no industry to speak of and no major exports to buoy the village through those dark, lean days, Balboa could easily have followed suit. It's saving grace? Balboa was a service town, and what it offered the crowds that arrived on overflowing Pacific Electric Red Cars from Los Angeles and beyond were powerful elixirs for a tired, beaten, and hungry nation. There was dancing. There was gambling. And despite Prohibition, if you knew the right person or could utter the correct catchphrase, there was booze.

Built in 1905, the Balboa Pavilion was, for many years, the only dance hall in town and, in its early days, may have been the only one in Orange County. It was an immediate draw, and at a time when dancing cheek-to-cheek was probably considered quite shocking, it was perhaps even sinful.

In the mid-1920s, the original Rendezvous opened. Hardly the ballroom it would later become, it was a tiny dance hall located where the empty shell of the Balboa Theater still stands today. The bands that played there, like the Oregon Aggravators, may have been unfamiliar with music terms like tempo and rhythm, but their enthusiasm resulted in the kind of raw, kinetic energy that can transform a dance like the Charleston into a frenzied celebration of that precise moment in time.

In 1928, the Balboa Beach Amusement Company built the new Rendezvous Ballroom, a block-long building on the oceanfront between Washington and Palm Streets. It had a 12,000-square-foot dance floor able to accommodate 1,500 couples, a 64-foot soda fountain on the ground floor, and another up on the mezzanine. It quickly became the premiere dance hall in Southern California. The ballroom's owners, R. G. Burlingame, Pop Tudor, and L. L. Garrigues, recognized the emerging popularity of big band jazz and decided the Rendezvous needed quality music. They hired a piano player named Carol Loughner to put together a house band.

In those days, all the big acts played the ballroom. Benny Goodman, Bob Crosby, Lawrence Welk, Phil Harris, Stan Kenton, Les Brown, Harry James, Spade Cooley, Nat King Cole, Guy Lombardo, Xavier Cugat, and Johnny Mercer all made frequent appearances and often broadcast on nationwide radio programs.

And the people came in droves. There were swing dancers from all over Southern California, servicemen from the nearby Santa Ana Air Base, and the legions of young people that invaded Balboa annually during spring break for "Bal Week." Their destination was the Rendezvous—the epicenter of town and, perhaps, the county.

In 1935, fate tried to deal a fatal blow in the form of a burning cigarette left in overstuffed upholstery. The Rendezvous burned to the ground. But the music didn't die. The ballroom was immediately rebuilt, and in 1938, *Look Magazine* crowned it the "King of Swing."

There was a time in Balboa history, from the late 1920s to the mid-1930s, when every other business on Main Street afforded its customers the opportunity to lose their hard-earned money through games of chance. In this regard, some have postulated that Balboa's moniker "Sin City" is less accurate than the more direct "Sucker City." The odds were far from even in gambling parlors run by Hutch Hutchison, Al Rothgary, and Dad Workman, where a form of roulette was the game of choice. Bingo and punchboards were other opportunities for the house to separate tourists from their pocket change.

In Balboa, gambling was legal in a sense. The city did, in fact, license the practice and collected significant licensing fees from it. Jack Summers, a part-time cop and part-time license collector, kept a sharp eye on the gambling establishments, making sure the city got its cut. But by state law, gambling was illegal. So it was that, on occasion, Balboa's gamblers and merchants would receive mysterious telephone calls affording the gambling establishments the opportunity to close and the merchants the chance to hide the punchboards and slot machines that they often kept conveniently near the cash register. Soon after, the sheriff from Santa Ana would appear, strolling up and down Main Street. Once satisfied that there was no gambling in Balboa, he would return to Santa Ana, and the gambling joints would reopen their doors, and the slot machines and punchboards would reappear.

There is a romantic notion of rumrunners during Prohibition, silently guiding their alcohol-laden boats through thick fog in the wee hours of the morning. But it happened a little differently in Balboa. Tony Cornero was a rumrunner who kept his ship, the *Rex*, moored 12 miles off the California coast. He sent speedboats to Balboa to deliver cases of alcohol that his men would unload right on the city dock out in the open. Numerous black sedans would line up on Washington Street. The drivers would take the cases allocated to them and head back up to Los Angeles. Local bootleggers included the Breakers Pharmacy, where it would have been difficult to find medicine of any kind, but for two bits, the druggist would sell an ounce of straight grain alcohol, the liquor of choice in Balboa. Dad Workman, one of Balboa's infamous gamblers, would sell an ounce for a knowing glance and a request of a carton of cigarettes.

Of course, mixing alcohol with the wall-to-wall revelers that paraded up and down Main Street in those days meant a bunch of drunks just looking for a fight. Local police arrested 50 to 75 people a night on charges of public drunkenness. Often the firehouse would be enlisted to house the overflow from the crowded jail.

These days there is nowhere to dance or gamble in Balboa. A visitor can buy a drink at any number of places, and occasionally a drunken brawl will start with a punch thrown outside a bar and end with two grown men wrestling on the beach.

Balboa still has an edge, as does any town that has a huge influx of visitors between Memorial Day and Labor Day, but it is not the "Sin City" that it once was. The following pages offer an opportunity to look back at those days with fondness.

One

BUSTLING BALBOA

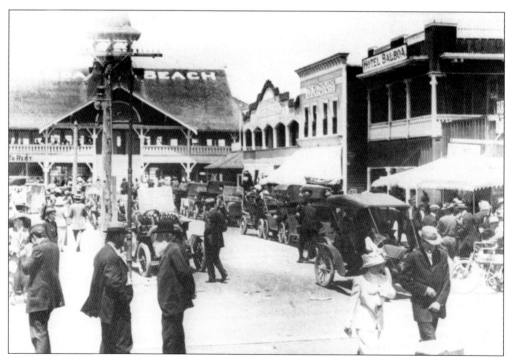

This *c.* 1911 photograph shows Main Street in Balboa. On the left, steps rise from the street to the Pavilion's second-story dance floor. On the right, F. W. Harding's Perfection Apartments are visible, followed by the Netherlands Apartments, and finally the Hotel Balboa. (Delaney collection.)

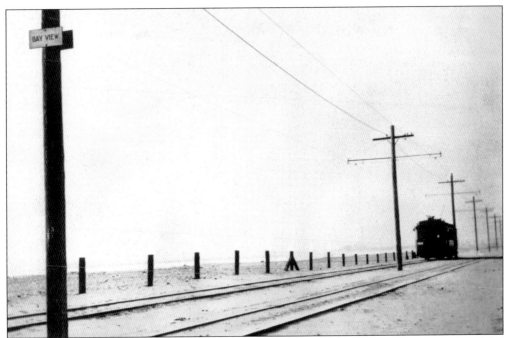

While the first Pacific Electric Red Car reached Newport on August 3, 1905, it wasn't until the following year that the line was extended two miles down the peninsula to Balboa. On July 4, 1906, one thousand passengers aboard 80 cars arrived from Los Angeles, mostly from Pasadena, and were welcomed by a giant barbecue, fireworks, and a persuasive sales pitch from local realtors. (First American Corporation Archive.)

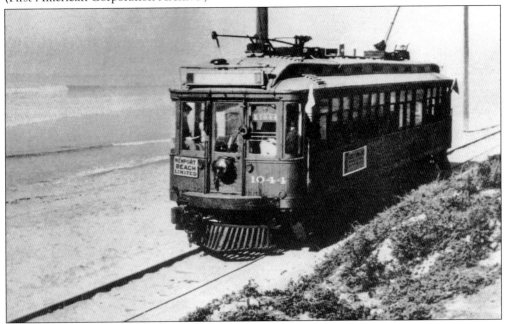

By 1911, Red Cars appeared on an hourly schedule with 19 round-trips daily, greatly contributing to Balboa's fame as a summer recreation center. Passenger service to Balboa came to an end on June 9, 1940. (First American Corporation Archive.)

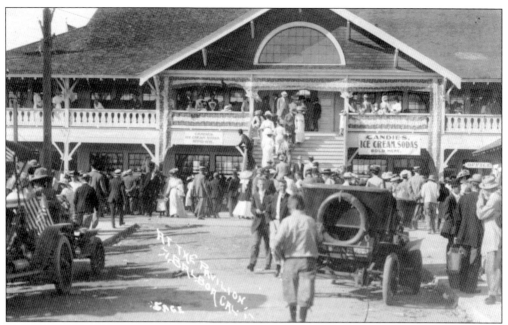

In the spring of 1905, the Balboa Pavilion was built by Chris MacNeil for the Newport Bay Investment Company. Lumber for the structure was barged in, as neither a railway nor a wagon road to Balboa existed at the time. This photograph is from 1912. (Delaney collection.)

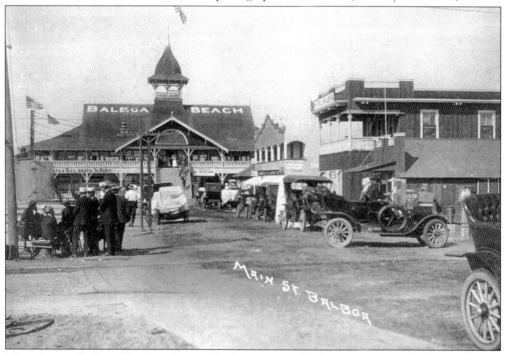

The 15-room Balboa Hotel, right, was built in a mere 10 days in 1906. Probably never once described as "swanky" in all its years of operation and almost certainly noncompliant with today's safety standards, it nevertheless offered visitors a place to hang their hat after a day at the beach or an evening of dancing. (First American Corporation Archive.)

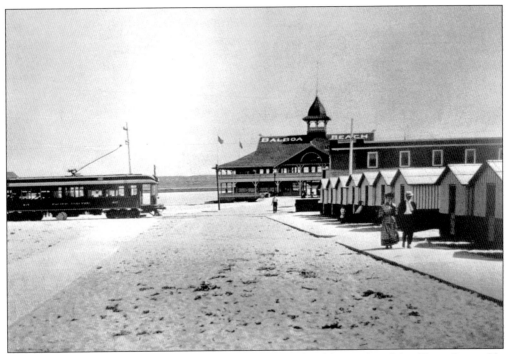

Everett Chase first came to Balboa in 1903 and bought eight old tents from Mrs. Harry Burns. He moved them to this location on the corner of Main Street and Central Avenue and eventually converted the tents to the cottages shown here. (First American Corporation Archive.)

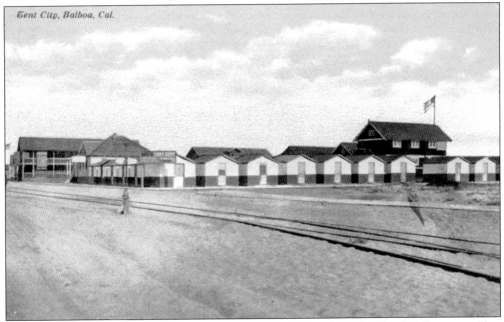

The cottages benefited from a great deal of overflow business from the Hotel Balboa, as well as visitors looking for a more affordable accommodation. The structure on the far left behind the cottages is the Ocean Swell Apartments. Built in 1908, they stood at the present corner of Balboa Boulevard and A Street. (Delaney collection.)

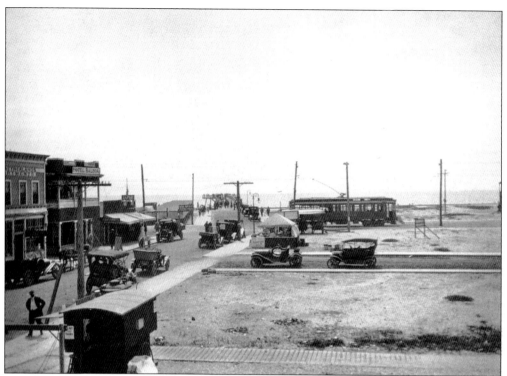

The Pacific Electric Red Car is depicted at the end of the line. Having departed from Los Angeles, its hour-long journey took it through Long Beach, Seal Beach, Huntington, Newport, East Newport, and finally, Balboa. The small stand on the corner offered ice cream cones, while the restaurant next to the Hotel Balboa offered fish dinners. (First American Corporation Archive.)

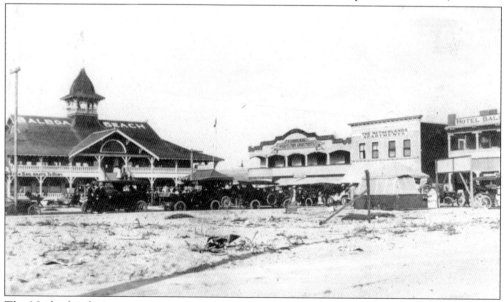

The Netherlands Apartments, right of center, were originally built in East Newport by John Meurs. Deciding Balboa would be a better location for the structure, he had it moved to Main Street in 1912. (First American Corporation Archive.)

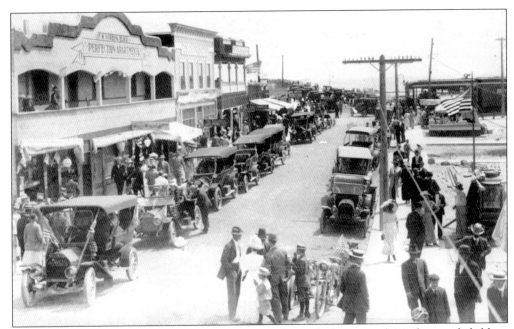

Just a few years later in 1915, the offerings on Main Street had improved. Mothers and children alike could find delights at the Cherry Blossom Confectionary, while the men could partake of the billiard parlor next door. Located on the first floor of the Netherlands Apartments, the poolroom was operated by W. L. Jordan, a conductor on the Pacific Electric run. (Delaney collection.)

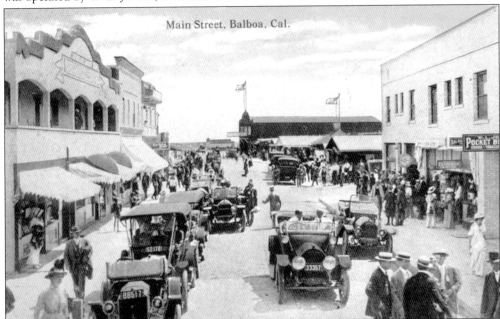

The building in the distance under the flagpole is the Balboa Theater that was built in 1913. Madam LaRue, whose real name was Mrs. W. A. Osgood, managed the theater from 1916 until it closed in 1928. LaRue, born in Tennessee in 1870, was known for her propensity for liquor and for being in possession of perhaps the most comprehensive lexicon of profanity the world has ever heard. (Delaney collection.)

A mother and son enjoy a day at Balboa in the early 1920s. Note the post office on the first floor of the Pavilion. A few years later, it would move across the street to the corner of Main Street and Edgewater Avenue. (Delaney collection.)

The first floor of the Hotel Balboa was occupied by the Liberty Café. It was named after its liberty sandwiches, which are best described as post–World War I hamburgers. (First American Corporation Archive.)

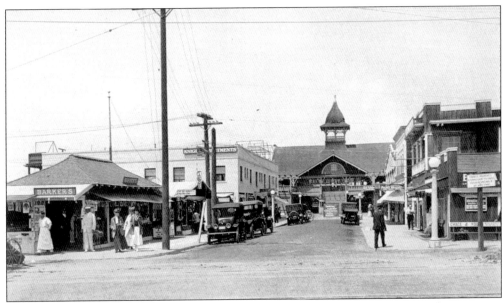

Barkers was one of several café/fountain service establishments that occupied the northwest corner of Main Street and Central Avenue prior to 1920. To the right of Barkers is Soto's Ping-Pong Stand and Chop Suey Parlor. Its owner, Sotojiro Nishikawa, had left his native Japan for San Francisco in 1903 aboard the *Hong Kong Maru*. By 1907, he had opened the ping-pong stand in the Pavilion, but he moved to this location in 1912. Over the years, the business morphed into a curio and novelty store much loved by generations of children. After Pearl Harbor, Soto, who had become one of the most popular men in town, was shunned. Puzzled and saddened by this turn of events, he nevertheless remained meek, polite, and cooperative. Not long after, he was shipped to Poston, a Japanese internment camp outside of Parker, Arizona, where summer temperatures can reach 120 degrees. Soto never saw his store again and died at the Orange County Hospital on June 27, 1949. (Both photographs First American Corporation Archive.)

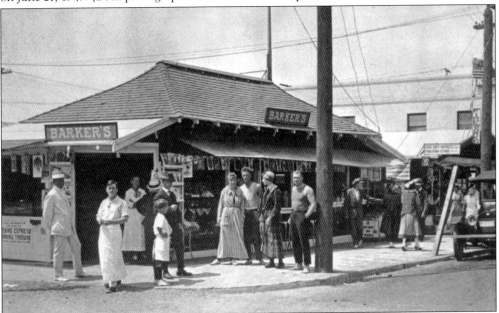

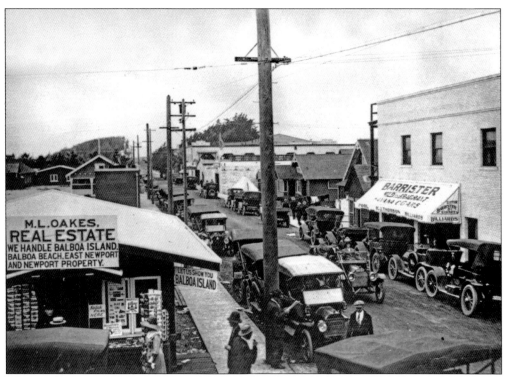

This 1915 view looks down Bay Avenue from Main Street. The M. J. Thomson Billiards Parlor occupies the first floor of the Knights Apartments and advertises "mild and fragrant Havana cigars." The tower on the left behind M. L. Oakes Real Estate is Balboa's first fire station. (First American Corporation Archive.)

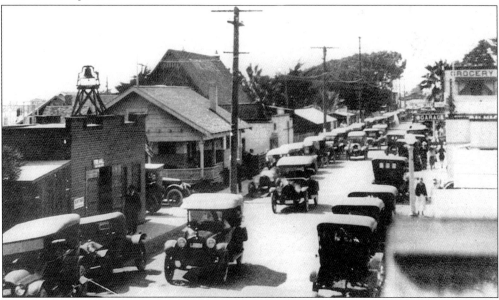

This is the same view from a different angle. The fire station is on the left under the bell tower. A plumbing business was operated out of the structure just beyond it with the flagpole. (Newport Beach Fire Department/the Crocker family.)

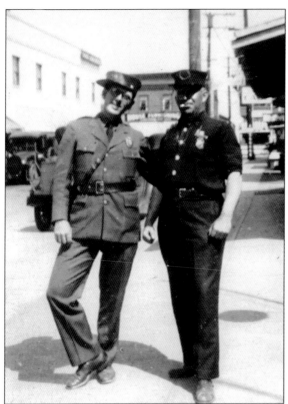

Frank Crocker, right, was the fire chief from 1927 to 1952. Because the fire department had the equipment to resuscitate water victims, Crocker also took over running the city's lifeguards in 1928. (Newport Beach Fire Department/the Crocker family.)

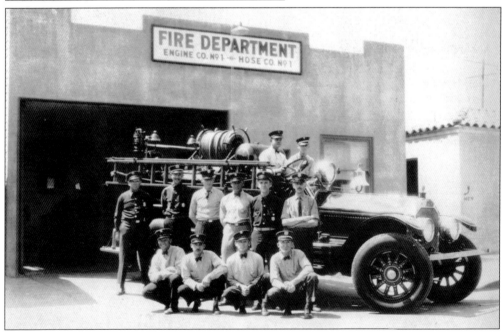

This is a later view of Engine Company No. 1 in the same location at 703 East Bay Avenue. On Saturday nights, when 50 to 75 individuals might be arrested for public drunkenness, the fire station doubled as a branch of the jail. (Newport Beach Fire Department.)

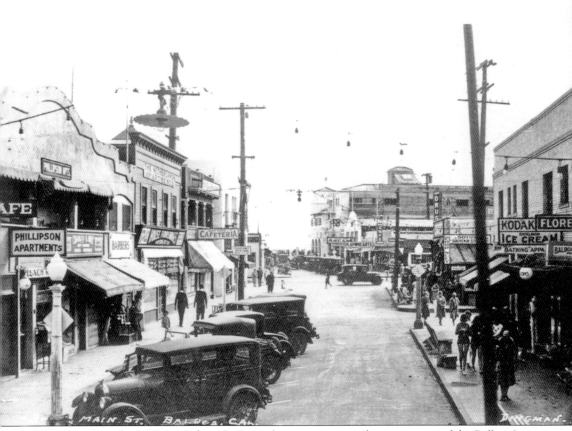

This view dates from 1930. Madame LaRue's theater is gone, and construction of the Balboa Inn at Main Street and Oceanfront is almost complete. An arcade is located next door. The Perfection Apartments are now the Phillipson Apartments, and Charles Way Dry Goods has moved into the first floor. The billiards parlor has left the Netherlands Apartment building, replaced by a house furnishings store owned by John Vogel. (First American Corporation Archive.)

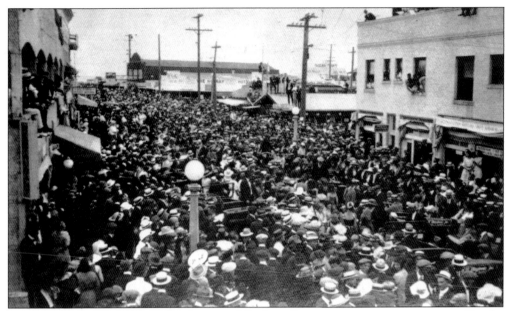

Crowds gather on Main Street for the annual Bathing Beauty contest, an event arranged by the chamber of commerce and Madame LaRue in the early 1920s to attract visitors to Balboa. (First American Corporation Archive.)

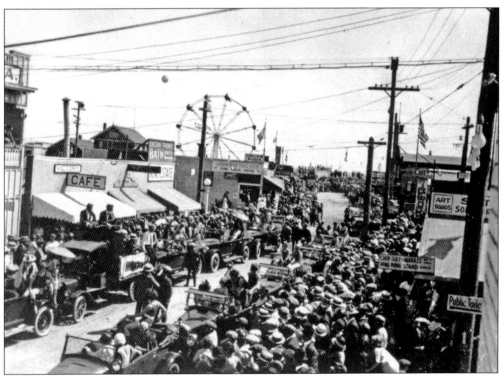

The bathing beauties became one of Balboa's most popular attractions, bringing as many as 25,000 visitors to the village. (First American Corporation Archive.)

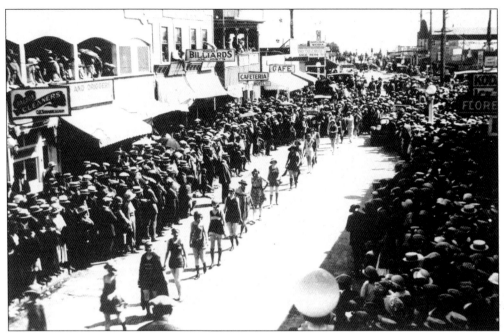

Madame LaRue had to import the girls for the contest because local girls would never be seen in such costumes. (First American Corporation Archive.)

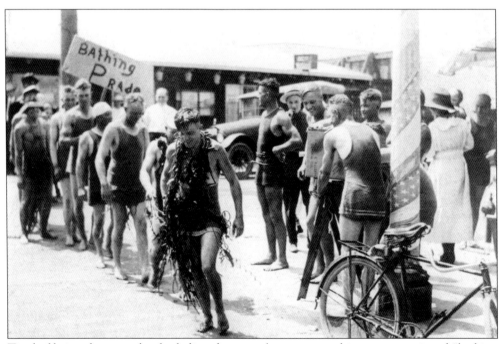

Tired of being shown up by the ladies, these gentlemen engaged in an unsanctioned "bathing parade" of their own. (Newport Harbor Nautical Museum Archive.)

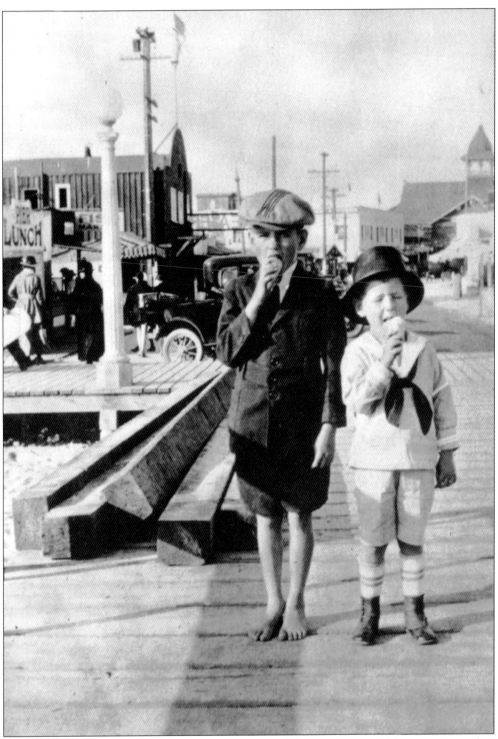

The style of clothing may change, but the appetite of the young for cold ice cream on a hot summer day remains unaltered in the 90 years since this photograph was taken at the base of the pier. (Delaney collection.)

The Business Street, Balboa, California.

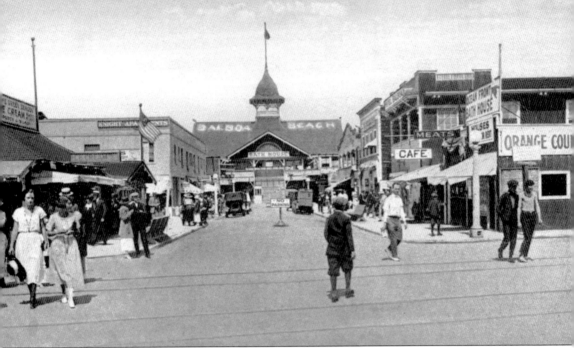

The Green Dragon, far left, owned at various times by Percy J. Wilson, James Givens, Dick Whitson, and Frank Finster, is shown in its original location on the northwest corner of Main Street and Central Avenue. In this location, it acted as a soda fountain, but when it moved across the street to the southwest corner in early 1924, it became a full-service restaurant and the place in town where everyone gathered. It was in the booths of the Green Dragon that Lloyd Claire, Frank Rinehart, Harry Williamson, Dick Whitson, Irvin George Gordon, and others plotted the 1928 revolution in which Balboa took over the political leadership of the city from old Newport. In those same booths, Harry Welch, A. B. Rouselle, and George Rogers dreamed up their plan to dredge the bay and make Newport Harbor the yachting center that it is today. (Delaney collection.)

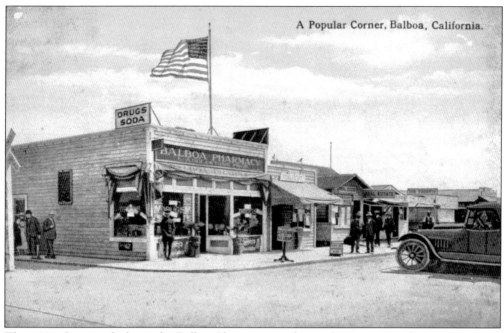

This 1921 photograph shows the Balboa Pharmacy on the southeast corner of Main Street and Central Avenue. Lewis Addlestone opened the business in 1920 but sold it within two years to Walter Eastlack. When construction of the Briggs building was completed on the northwest corner in 1924, Eastlack moved the pharmacy into the new building. A pharmacy has existed on that corner ever since. (Delaney collection.)

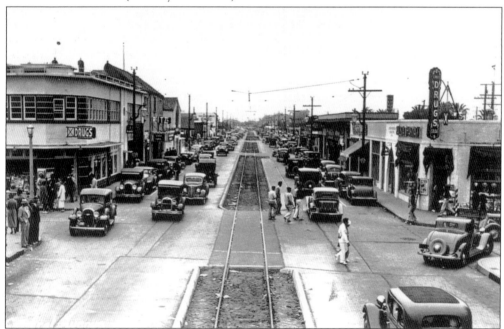

A westward view on Central Avenue is seen in 1936. On the left, the McCoy Drug Company has replaced the Green Dragon, which held the corner location from 1924 to 1935. (First American Corporation Archive.)

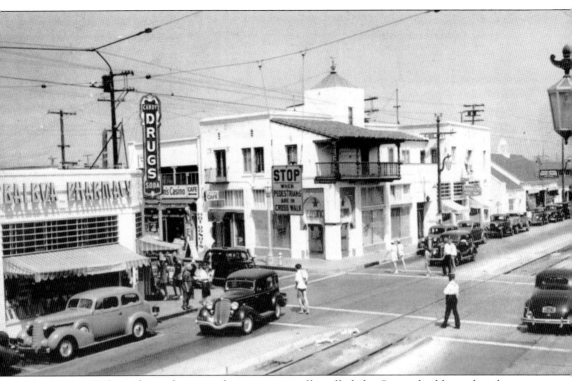

The Casino Café in shown here in what was originally called the Storey building, then later the Vogel building. From the late 1920s to the mid-1930s, about half the businesses on Main Street were gambling joints owned by Hutch Hutchinson, Al Rothgary, Dad Workman, and Al Anderson. A form of roulette was the game of choice with odds heavily favoring the house. Almost all business had slot machines and punchboards, often conveniently located near the cash register. Gambling was legalized and licensed in Balboa by a city ordinance, creating a cash cow for the city's coffers. The ordinance was in violation of state law, and as a result, local merchants and gambling joints often received mysterious tips that the sheriff from Santa Ana was en route. This left just enough time for the gambling joints to shut their doors and the merchants to hide their slot machines and punchboards in their back rooms. Gambling certainly contributed to Balboa's "Sin City" reputation, but it also helped keep the city afloat through the dark years of the Depression. This photograph is from 1937. (Delaney collection.)

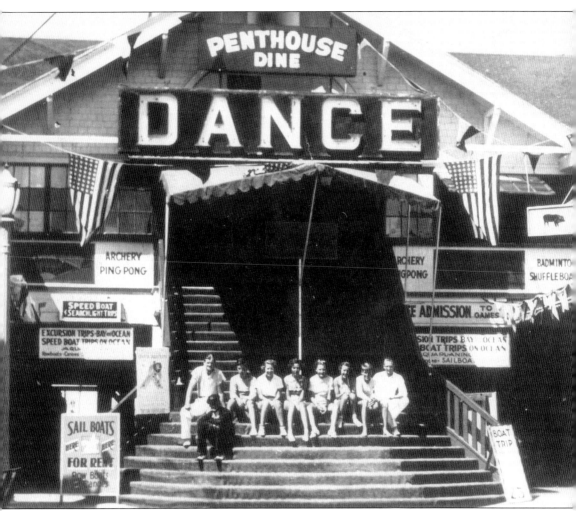

In its century-long history, the Pavilion has been home to numerous tenants, including restaurants, a sport fishing business, an art museum, a post office, gambling parlors, bowling alleys, a barbershop, and a ping-pong stand. (First American Corporation Archive.)

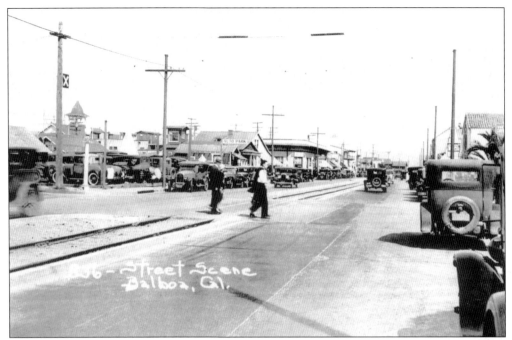

Pictured here is the intersection of Palm Street and Central Avenue, and these pedestrians may have just stepped off the ferry from Balboa Island. A portion of the Auto Park on the left is still a parking lot today. If one looks closely at the far right, the sign for Gus Tamplis's Sea Shell Café can be seen. (First American Corporation Archive.)

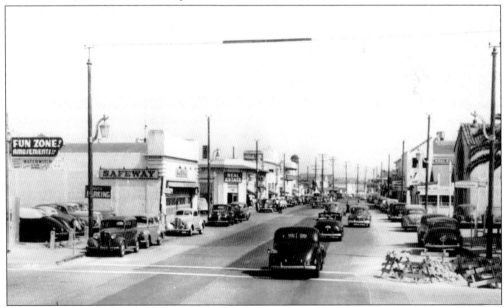

This 1948 image is of the same intersection almost two decades later. The building housing Safeway on the left eventually became the Balboa Market, which served the community and its visitors for many years. In 1995, Donald McDonald painted a wonderful mural on the west side of the building, depicting both Balboa's past and present. The market just recently closed its doors, and the building is currently for lease. (Delaney collection.)

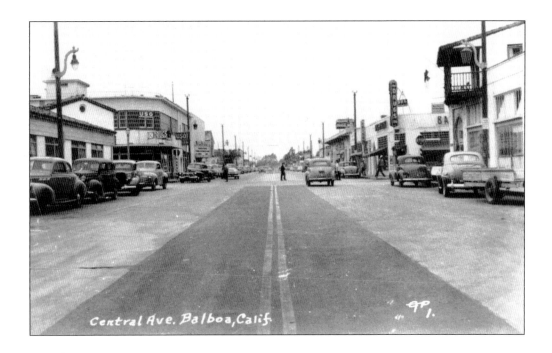

Central Ave. Balboa, Calif.

Henry Huntington operated the Pacific Electric Red Cars as a loss leader to connect city dwellers to his real estate developments in outlying suburban areas. When those land holdings became fully developed in the early 1920s, the least-used Red Car lines were replaced by buses, some as early as 1925. The last Red Car left Balboa on June 9, 1940, and the tracks were paved over, as seen in these two images from 1943 (above) and 1948 (below). (Both photographs Delaney collection.)

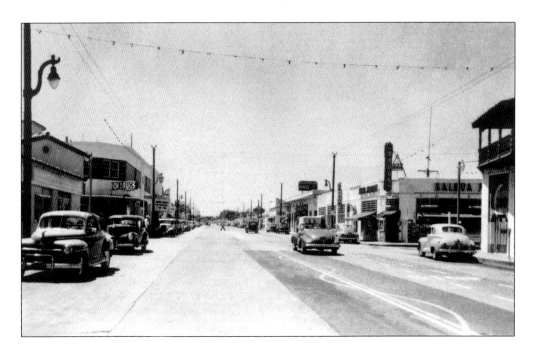

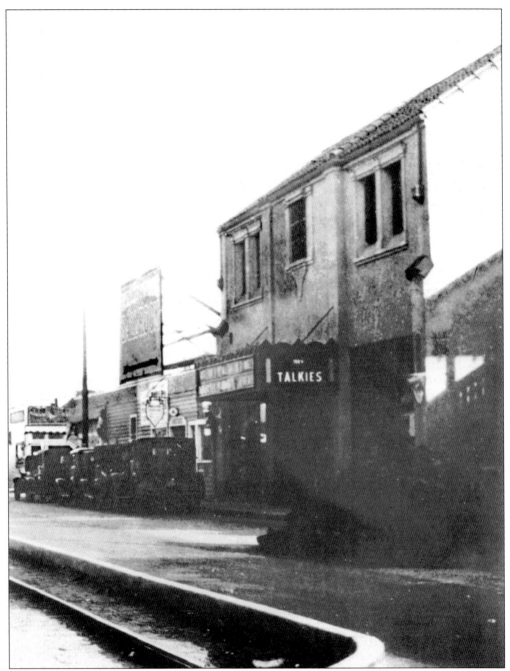

The Ritz Theater was built by the Balboa Beach Amusement Company in 1928. This 1929 photograph shows the marquee proclaiming "New Talkies." The structure became known as the Balboa Theater when Henry Siler, who had operated the Ritz, moved to the new Lido Theater in 1939. The Balboa Theater entertained generations of moviegoers until it closed its doors in 1992. The Balboa Performing Arts Theater Foundation hopes to reopen the venue as a multiuse facility for both live performances and films. (Sherman Library.)

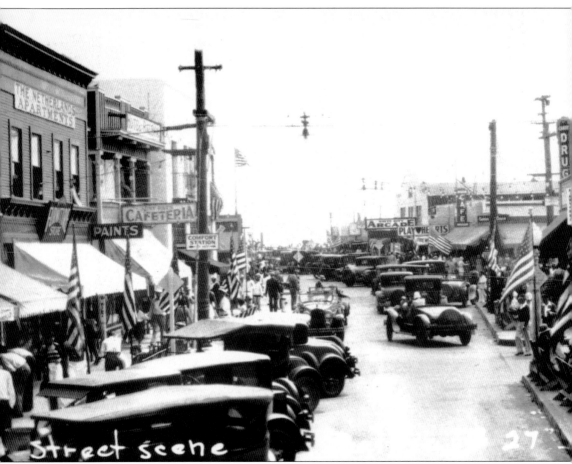

Balboa is at its most bustling in this 1930 photograph. Aunt Pat's Cafeteria now occupies the ground floor of the Balboa Hotel, the White City Arcade has replaced Madame LaRue's theater, the Green Dragon is enjoying its heyday on the corner of Main Street and Central Avenue, and a flapper is turning her convertible onto the main drag. (First American Corporation Archive.)

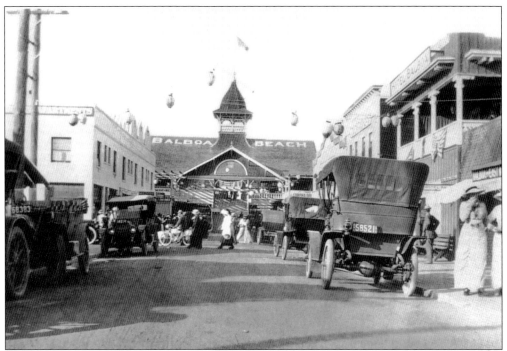

The Knight Apartments, shown on the left above *c.* 1914 and on the right below in 1944, were built by Frank J. Knight in 1913. Far from modern, the building contained single rooms with a shared bathroom at the end of the hall. The apartments were usually occupied from Memorial Day to Labor Day by the summer workforce. Lifeguards, waiters, cooks, dishwashers, gambling joint dealers, and bathhouse attendants would gang up to cut costs. The thriftier among them might even rent one of the drafty shacks on the roof. The building still stands, but the shacks are gone. (Both photographs First American Corporation Archive.)

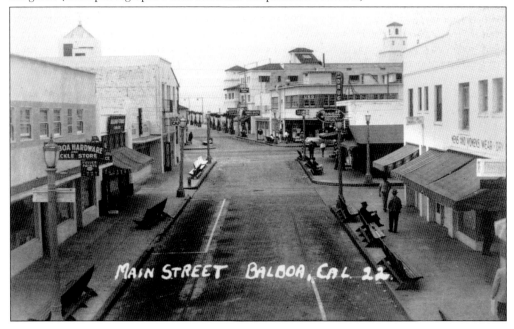

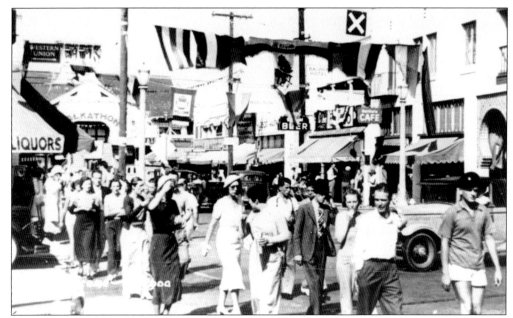

This image shows a busy day on Main Street during the Great Depression. While many small towns went bankrupt and vanished from the map, Balboa survived on its three major industries, dancing, gambling, and liquor. (Delaney collection.)

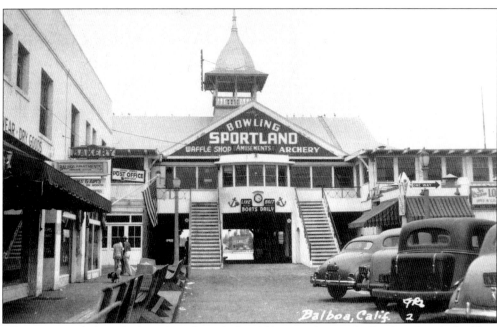

Efforts were made from the late 1930s through the 1950s to modernize the Pavilion, but the building fell into almost total disrepair. It was eventually saved by the Gronsky family, who replaced its understructure and most of its exterior. Much later, the Pavilion was sold to Phil Tozer, who, with his partners, completed the interior restoration. (First American Corporation Archive.)

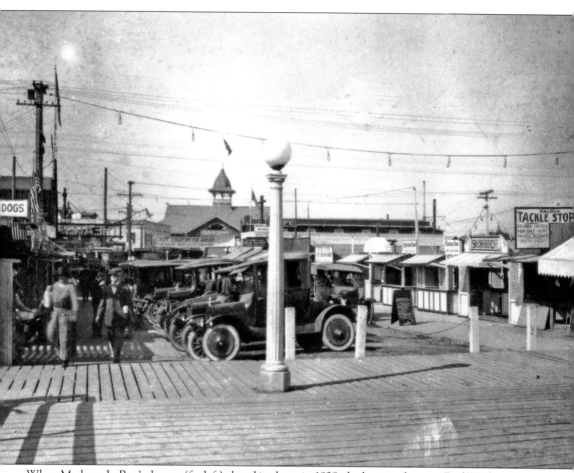

When Madame LaRue's theater (far left) closed its doors in 1928, the location became Dad Workman's gambling joint. Workman was also a good source for bootleg liquor. Customers in the know would express an interest in buying a carton of cigarettes, give him a knowing wink, and Workman would slip a bottle of alcohol into the carton. (First American Corporation Archive.)

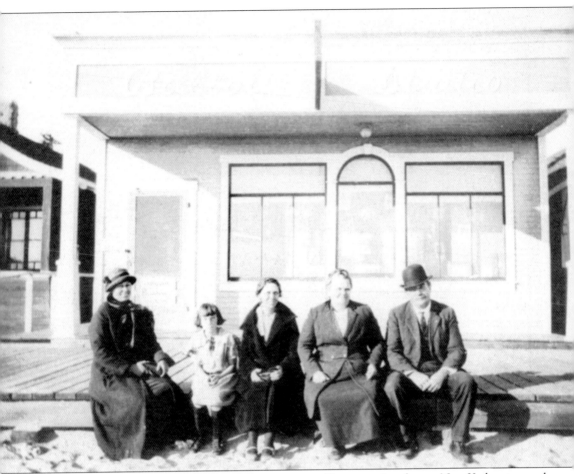

The Balboa Studio was run by Lou Anger, a pioneer film executive, former New York actor, and vaudeville star. After coming to California in 1916, he developed such film comedians as Fatty Arbuckle and Buster Keaton. Considered the king of slapstick comedy producers in the early days of film, Anger ran studios in Balboa, then Long Beach, and finally Hollywood in 1920. (Delaney collection.)

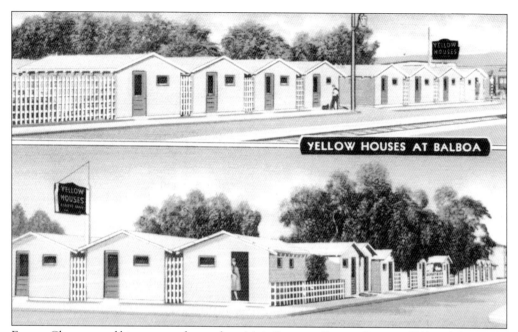

YELLOW HOUSES AT BALBOA

Everett Chase moved his converted tents from Main Street to Cypress Street in 1912 and christened them "Everett Chase's Little Yellow Houses." According to a postcard advertisement, they were furnished "in a most artistic manner" and included gas, electric lights, laundry, and house linen. His initial 24 cabins increased to 61 by the early 1930s. (Delaney collection.)

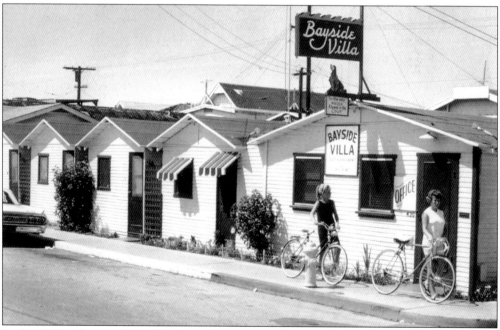

In the 1960s, what was left of "Everett Chase's Little Yellow Houses" became the Bayside Villas, advertised as "Just Klean Kabins!" (First American Corporation Archive.)

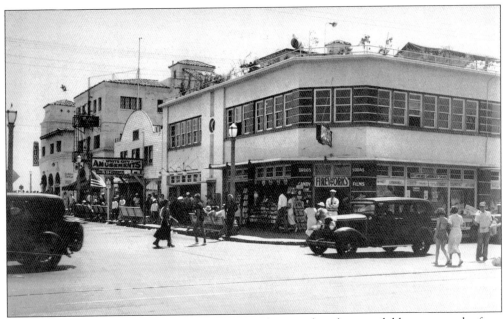

Just visible above the McCoy Drug Company is their roof garden, available to passersby for a nominal fee from the late 1930s to early 1940s. The roof also offered a fine view of the village. (Delaney collection.)

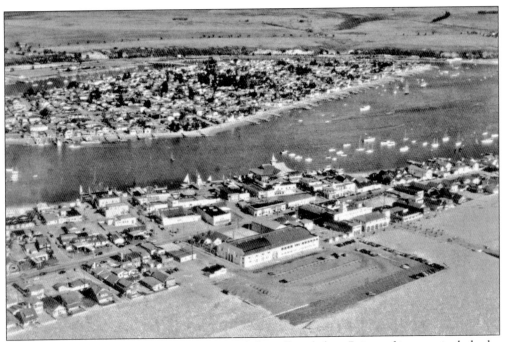

An aerial view shows Balboa Island above and the village below. Points of interest include the Fun Zone, the Pavilion, the Vogel building, the Balboa Inn, the Rendezvous ballroom, and the new municipal parking lot. (First American Corporation Archive.)

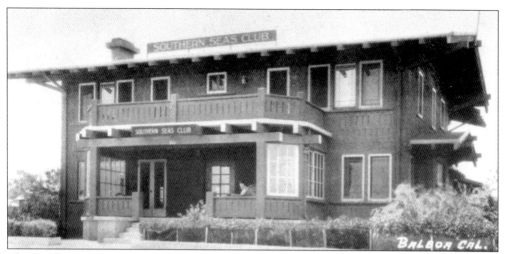

The Southern Seas Club, located on the bay front between Cypress and Fernando Streets, acted as the sales office for Lido Island land sales in 1930. Later it was converted into the Palisades Restaurant. (First American Corporation Archive.)

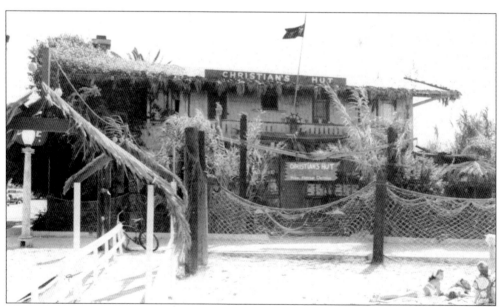

After the Palisades Restaurant closed its doors, Art LaShelle draped the building with netting, added a dock, and introduced the Tahitian-style restaurant Christian's Hut. The sand-floored, ground-level bar was frequented by the likes of Errol Flynn, Humphrey Bogart, and Fred MacMurray. Unruly guests at Christian's Hut were not only thrown out, they were often carried to the end of the dock and tossed into the bay. (Delaney collection.)

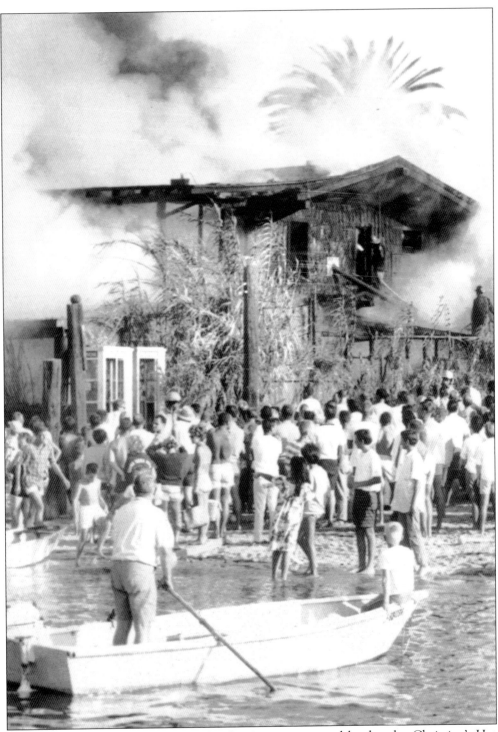

The 1960s were not kind to some of Balboa's most treasured landmarks. Christian's Hut fell to fire in 1963. Currently, the site is occupied by the Newport Towers. (First American Corporation Archive.)

Two

SOME OF OUR ATTRACTIONS

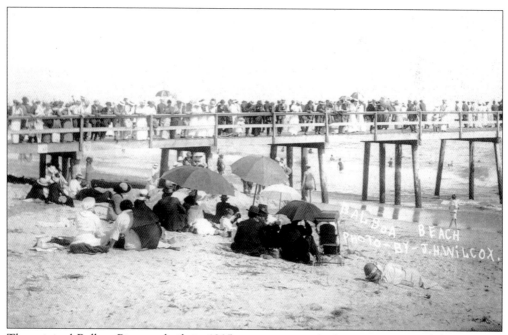

The original Balboa Pier was built in 1905, concurrent with the construction of the Pavilion, as an added attraction for visitors taking the Red Car down from Los Angeles. (First American Corporation Archive.)

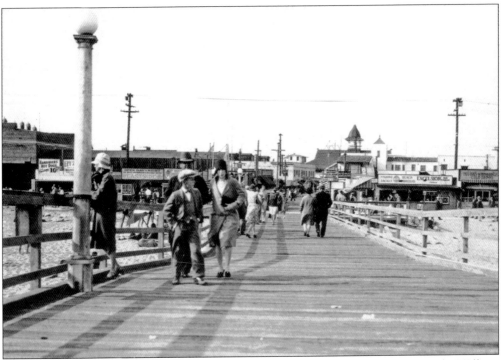

A new pier was built in 1921 when a $25,000 bond issue was passed by a large margin. The William Ledbettor Company won the contract. Initial plans overlooked a lighting system for the pier, which was added later at an additional cost. (First American Corporation Archive.)

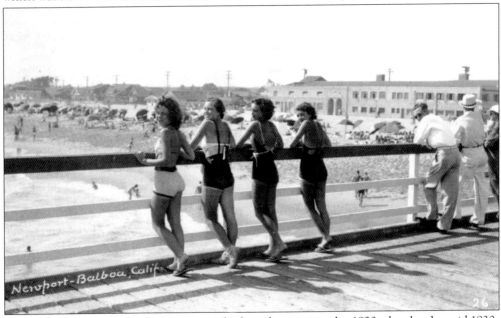

Madame LaRue may have had to import bathing beauties in the 1920s, but by the mid-1930s local girls had risen to the challenge. Spending their days on the beach and the bay, these four beauties almost certainly spent their evenings at the Rendezvous Ballroom (on the right). (Delaney collection.)

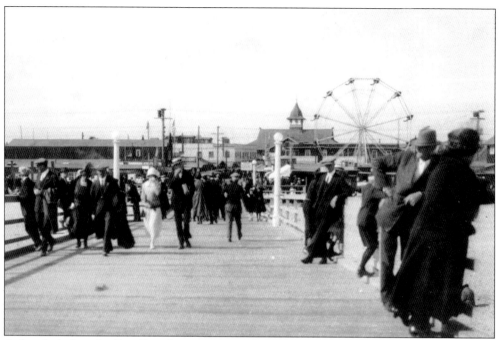

A decade before the Fun Zone became a tourist destination on the bay side of the peninsula visitors enjoyed a Ferris wheel on the beach side. (Delaney collection.)

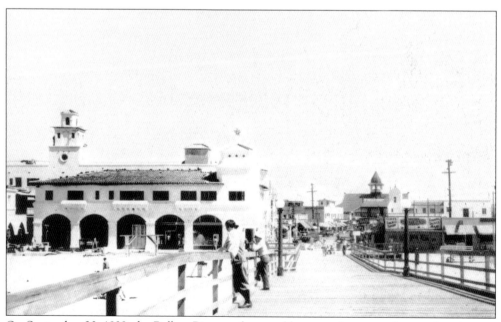

On September 20, 1939, the Balboa Pier was destroyed by a massive storm that produced waves that eyewitnesses described as three stories high. The pier was rebuilt the following year. (First American Corporation Archive.)

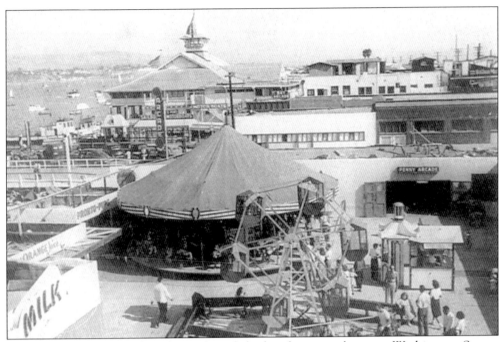

In 1936, entrepreneur Al Anderson leased the bay front area between Washington Street, Palm Street, and Bay Avenue from Fred Lewis. Anderson cleared the land and began putting up amusement features. He christened his new amusement park the Fun Zone. Over the years, he added more games and rides, including bumper cars, a merry-go-round, and a Ferris wheel. (Sherman Library.)

The FUN ZONE, on the Bay Front At Balboa was planned, built and is operated—

JUST FOR FUN!
AND NOTHING ELSE

Here you can achieve the thrill of an airman's view from the safety seats of the Ferris Wheel, swing with assorted, colorful and captive animals on the Merry-Go-Round, try your hand at beating William Tell's archery record, make Babe Ruth's home-run record look silly at the Zone's trick baseball game, replenish your academic interest in art at the Penny Arcade and win the right to manage Pop-Eye, the sailor man, Mr. Wimpy, or Mae West by simply upsetting the Pyramids—of unbreakable bottles of synthetic milk — AND IT'S ALL FOR FUN AT THE

FUN ZONE

COME! JOIN THE BIG "EASTER PARADE"

This 1938 clipping from the *Balboa Times* invites visitors to the Fun Zone to "achieve the thrill of an airman's view from the safety seats of the Ferris wheel." (Delaney collection.)

Pamela Whitford takes in the sights and sounds of the Fun Zone in 1946. (Brigandi collection.)

FUN ZONE
• AT BALBOA •
Opens Saturday
• AND YOU'RE INVITED •

Where the "Early Season" Amusement Seeker will find a gorgeously lighted and shiny

FERRIS WHEEL
— and a —
MERRY-GO-ROUND
Featuring Polite Music and Hosses with Lavendar Eyes — —
— and a —
BASEBALL GAME
With a Robot Pitcher of uncertain control and a Dizzy Dean temperament — —
— and —
SKEE BALL — THROW GAMES
• ARCHERY •

— — AND OTHER CONCESSIONS designed solely for your amusement and to challenge your skill. For the marine minded there are Sail Boats, Electric Motor Boats and Kayaks For Rent.

Another 1938 clipping promotes other amusements, including "a merry-go-round with polite music and hosses with lavender eyes!" (Delaney collection.)

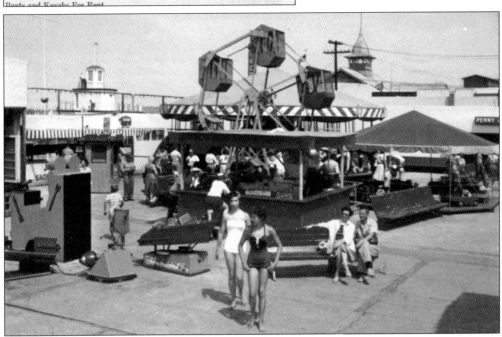

In 2005, thirty-four thousand square feet of property in the Fun Zone and the adjacent docks was purchased by the Newport Harbor Nautical Museum. According to the museum's Web site, their goal is "to become a world-class showcase for regional, national, and international nautical and maritime history." (Delaney collection.)

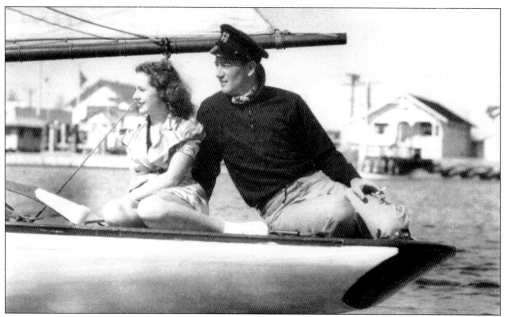

Celebrities have made frequent appearances in Balboa over the years. Pictured here in the late 1930s, John Wayne cruises the harbor with his good friend Barbara Read. Back in 1926, Wayne was a promising 19-year-old tackle for the University of Southern California Trojans football team. While surfing near the Balboa Pier, he guessed wrong on a wave and tore a ligament in his shoulder, ending a promising career in football. (Newport Harbor Nautical Museum Archive.)

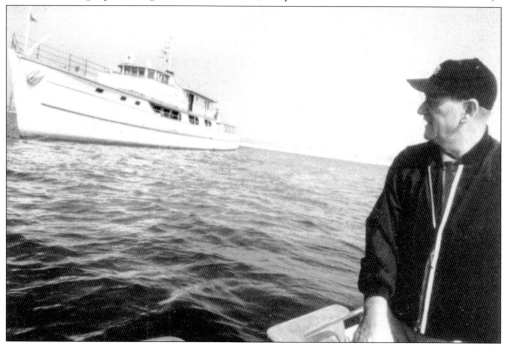

John Wayne is seen with the *Wild Goose*, a 136-foot converted U.S. Navy minesweeper. The aging yacht was the actor's prized possession and a means to retreat from the spotlight and enjoy precious time with family and friends. (Newport Harbor Nautical Museum Archive.)

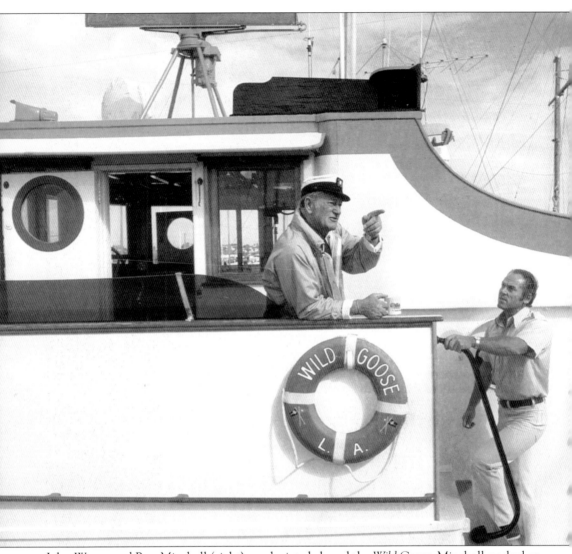

John Wayne and Bert Minshall (right) are depicted aboard the *Wild Goose*. Minshall worked on the aging yacht for 16 years, starting as a deckhand and ending as the last skipper under Wayne's ownership. He was a good friend of the Duke. (Newport Harbor Nautical Museum Archive.)

John Wayne stands outside the wheelhouse while his son Ethan and daughter Aissa play by the *Wild Goose*'s brass helm. (Newport Harbor Nautical Museum Archive.)

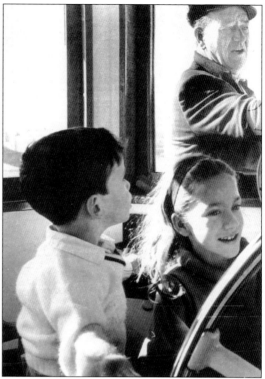

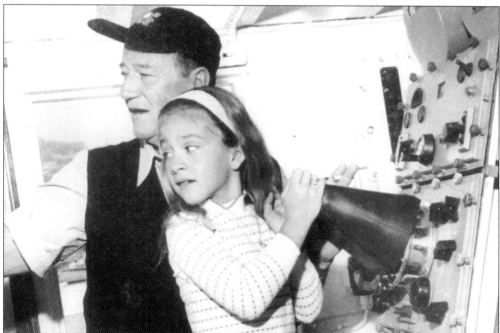

John Wayne and his daughter Aissa are seen in the wheelhouse in 1963. After Wayne's death, the *Wild Goose* found new homes in San Pedro, Long Beach, and Marina del Rey, but it has since returned to Balboa. Now a charter boat, it is often used for weddings and other occasions. The old minesweeper is a frequent site in Balboa Bay. (Newport Harbor Nautical Museum Archive.)

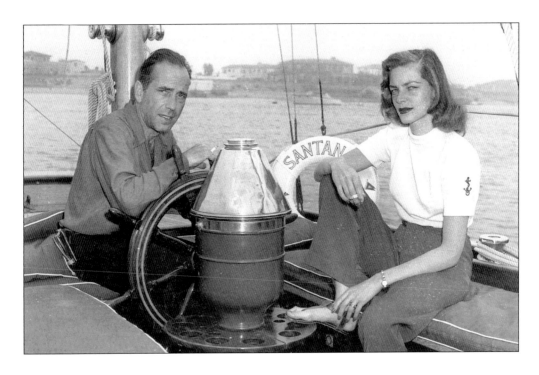

In the early 1940s, Humphrey Bogart romanced Lauren Bacall at the Balboa Bay Club, and the couple spent their honeymoon here in 1945. Above, they sail the harbor aboard Bogart's 57-foot yawl *Santana*. (Newport Harbor Nautical Museum Archive.)

Ray Milland, an Oscar winner for best actor for *The Lost Weekend* (1945), is seen here with his wife, Mal, and son Danny at their new home in Balboa on July 13, 1946. Milland was fond of fishing and boating, both activities available from his front door. (Delaney collection.)

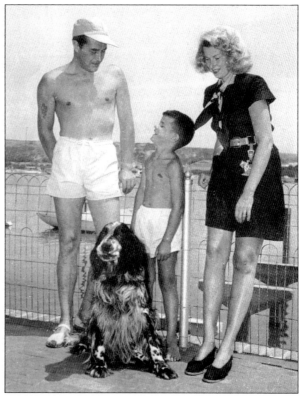

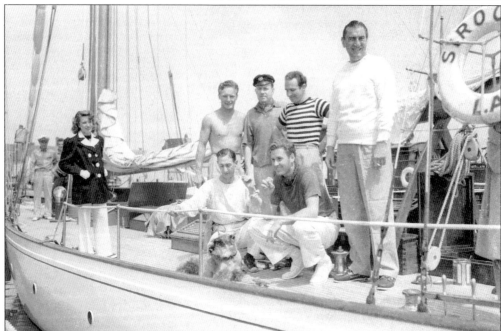

Errol Flynn is seen here with friends and crew aboard the large sailing craft *Sirocco*. Flynn was a frequent visitor to Art LaShelle's Christian's Hut and occasionally to Bill Ireland's joint on Main Street, and he kept the *Sirocco* docked in Balboa Bay. (First American Corporation Archive.)

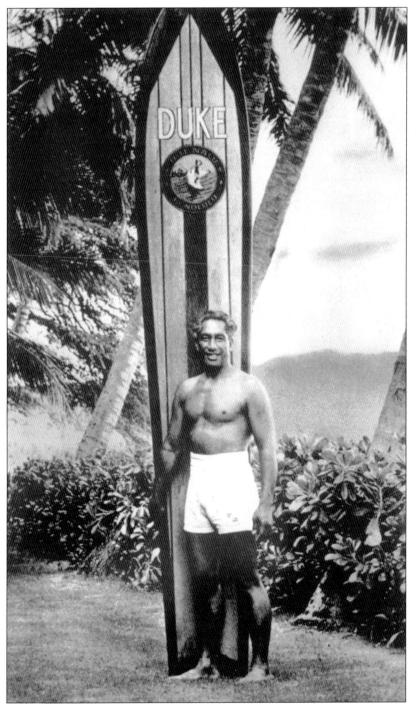

The legendary Duke Kahanamoku, a gold medal winner for swimming in the 1912 and 1920 Olympic Games, is also credited with popularizing the sport of surfing, both in the United States and Australia. On June 14, 1925, Kahanamoku was sleeping in a tent on the beach when he saw the launch *Thelma* overturn at the harbor entrance. Using only his surfboard, he rescued seven men from the heavy seas. (City of Newport Beach.)

In 1938, the *Balboa Times* referred to "Bal Week" as "the Easter respite from scholarly obligations that annually sends thousands of youth to Balboa." Those same youths might more accurately describe it as a weeklong, nonstop party. Local merchants would describe it as a much-needed injection of business after a long winter. (Newport Harbor Nautical Museum Archive.)

City employees on Balboa Island remove benches from Marine Avenue in preparation for the Bal Week chaos in this 1950s photograph. (*Daily Pilot*.)

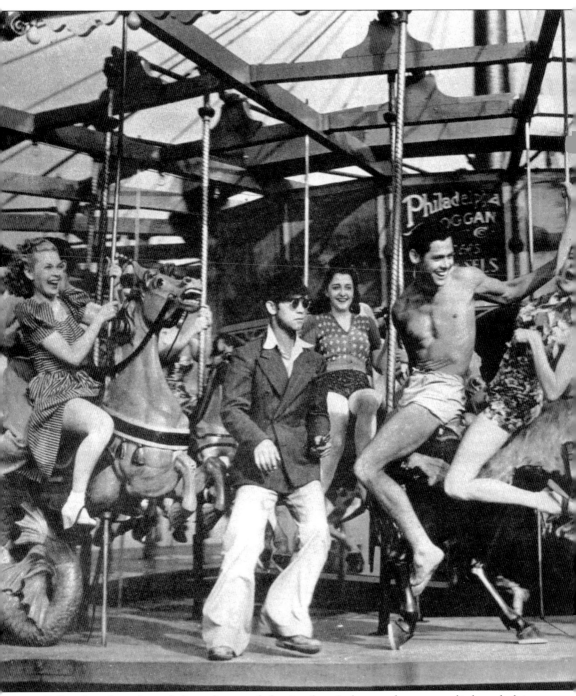

Balboa has always been dedicated to people having fun. As long as they spent a little cash doing it, especially during Bal Week, mischief and misbehavior could be forgiven. Early lawmen Jesse Elliot and Jack Summers knew how to handle the Easter crowds—a little law enforcement, but not too much. The carousel, pictured here in 1940, was made by the Philadelphia Toboggan Company. It was later moved to Happyland in Venice, California, and then to Streamland Park in Pico Rivera. (Delaney collection.)

As seen here in 1940, neither music, nor a dance floor, nor proper shoes were necessary if the mood struck a young couple to dance. Sometimes a dock in the bay will do just fine. (Delaney collection.)

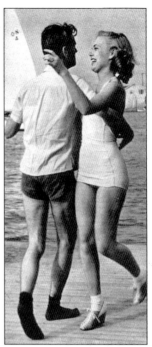

Boys cruised Main Street and Central Avenue in their cars, whistling and honking at the girls on the sidewalks. The girls pretended not to notice. (Delaney collection.)

The sorority girl's code of behavior went as follows: it was considered illegal to take a date away from another girl in your own sorority, but luring boys away from girls in other houses is considered a triumph. These photographs were taken in 1940. (Both photographs Delaney collection.)

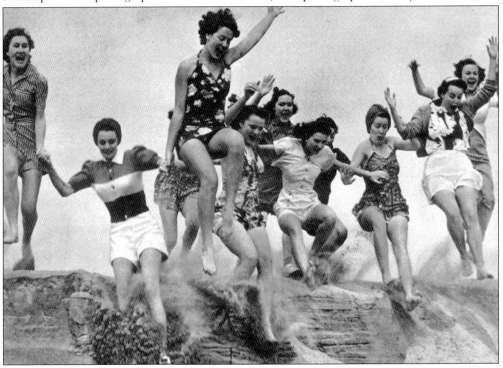

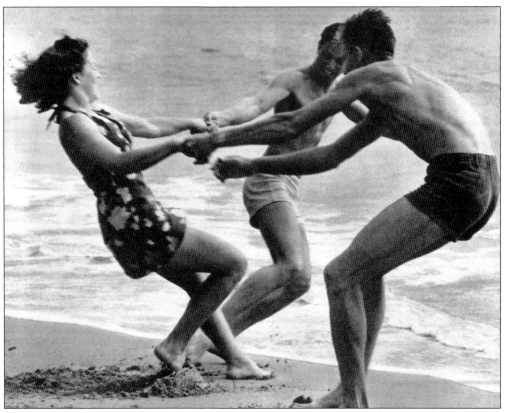

Days were spent making friends on the beach or engaging in games of chance in the Fun Zone, seen here in 1940. (Both photographs Delaney collection.)

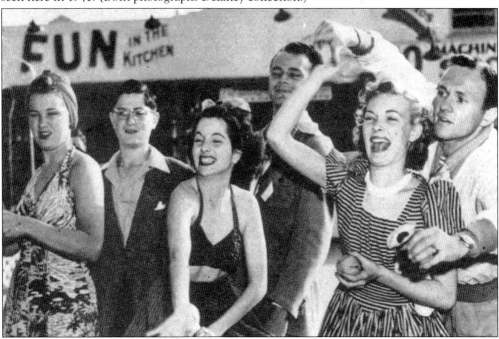

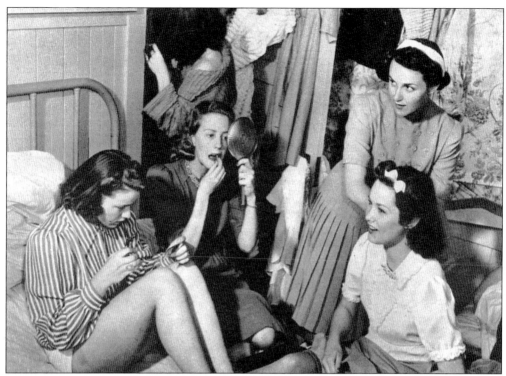

Nights were all about getting ready for the big dance, depicted here *c*. 1940. (Delaney collection.)

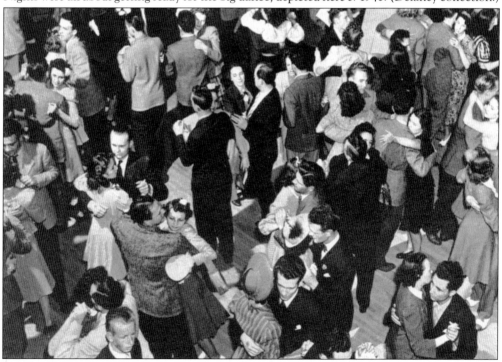

From generation to generation, one thing never changed: the mecca for Bal Week was the Rendezvous Ballroom, seen here in 1940. (Delaney collection.)

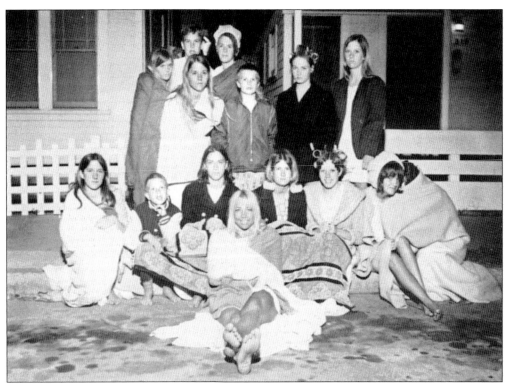

To rent a cramped beach cottage or small apartment, a reservation was needed months prior to spring break. Then dozens of friends were invited to share the space and the rent. (*Daily Pilot*.)

Young men find the optimal vantage point to watch the girls. (*Daily Pilot*.)

Girl watching is an art in Balboa, requiring years of study and practice. Some brazenly stare, others pretend not to look at all, but the wisest know to wear sunglasses so no one can tell who is watching whom. (*Daily Pilot.*)

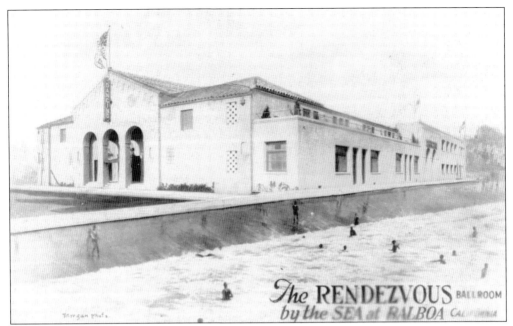

The RENDEZVOUS BALLROOM
by the SEA at BALBOA Cal.

In 1928, the Balboa Beach Amusement Company built the Rendezvous Ballroom, signaling the beginning of the big band era in Balboa. The block-long building, located on the oceanfront between Washington and Palm Streets, was constructed at a cost of $200,000. (Delaney collection.)

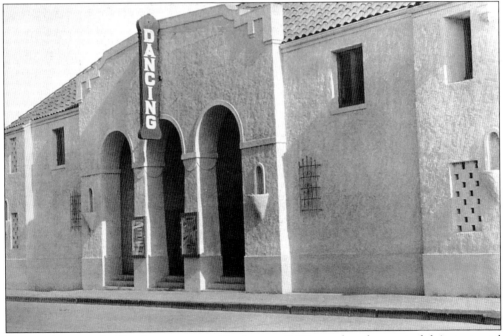

In its early years, the Rendezvous opened its doors at 8:00 p.m., but the music didn't start until 9:00 p.m. At that hour, a recording of "Avalon" played over the hall's public address system as the musicians made their way to the bandstand and found their instruments. Then the recording would fade, the band would take up the next verse, and the dancing would begin. (First American Corporation Archive.)

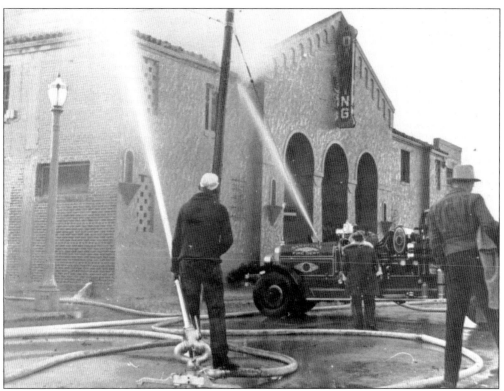

The Rendezvous burned down in 1935 in a blaze attributed to a smoldering cigarette left in overstuffed upholstery. (Newport Harbor Nautical Museum Archive.)

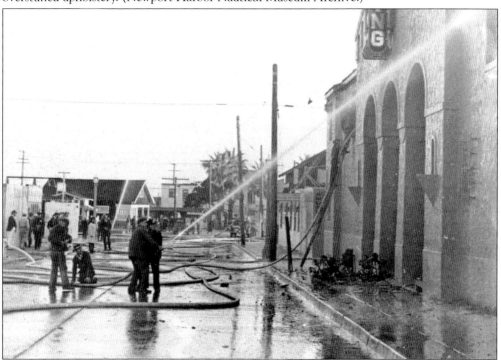

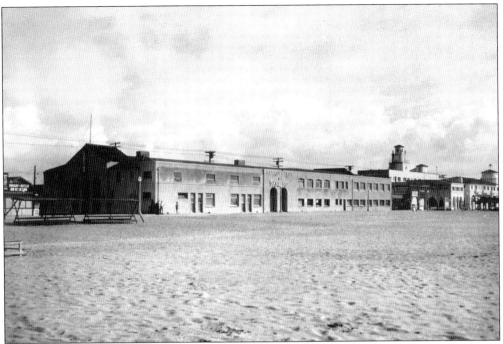

The Rendezvous was immediately rebuilt and continued to attract such acts as Benny Goodman, Bob Crosby, Lawrence Welk, Phil Harris, and Stan Kenton. (Newport Harbor Nautical Museum Archive.)

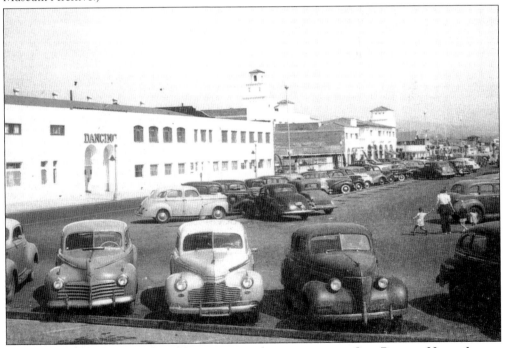

During World War II, other big names made appearances: Les Brown, Harry James, Spade Cooley, Nat King Cole, Guy Lombardo, Xavier Cugat, and Johnny Mercer. (First American Corporation Archive.)

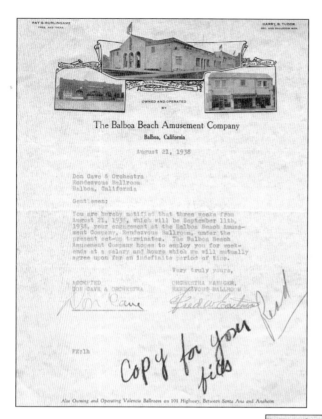

A letter dated August 1938 from the Balboa Beach Amusement Company informs Don Cave and his orchestra that their contract to perform at the Rendezvous Ballroom is about to expire and expresses a desire to renew the contract under terms to be mutually agreed upon. (Delaney collection.)

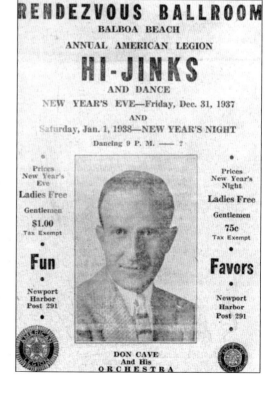

A 1937 advertisement from the *Balboa Times* promotes a New Year's Eve "hi-jinks and dance" at the Rendezvous with Don Cave and his Orchestra performing. (Delaney collection.)

On June 18, 1938, a unique event took place at the Rendezvous. The popularity of swing music reached its zenith when 5,000 "cats" and "alligators" rose at dawn to "cut rugs" and "kick out" at 6:00 a.m. The occasion was a "jam session" or "swingaree" staged by radio station KEHE to celebrate the end of the school year. (Both photographs Delaney collection.)

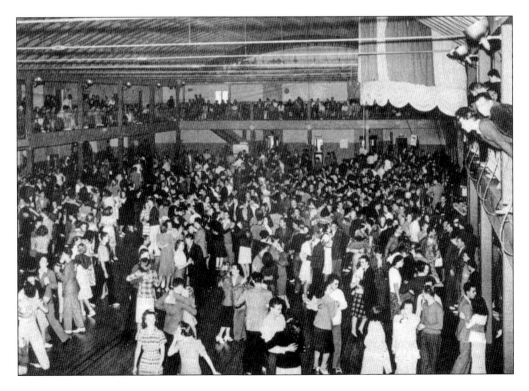

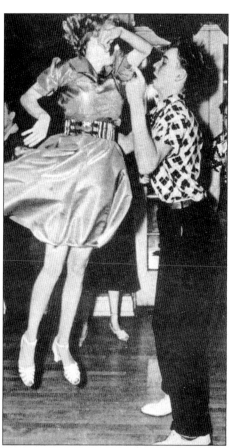

These two dancers slept in the ballroom the night before the dance to make sure they would not be late. (Delaney collection.)

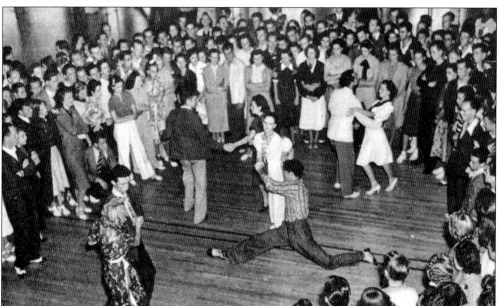

At least at this event, Roy Damron, doing the splits as a member of the Alhambra Alligators, was considered the "king of swing." The photograph dates to 1938. (Delaney collection.)

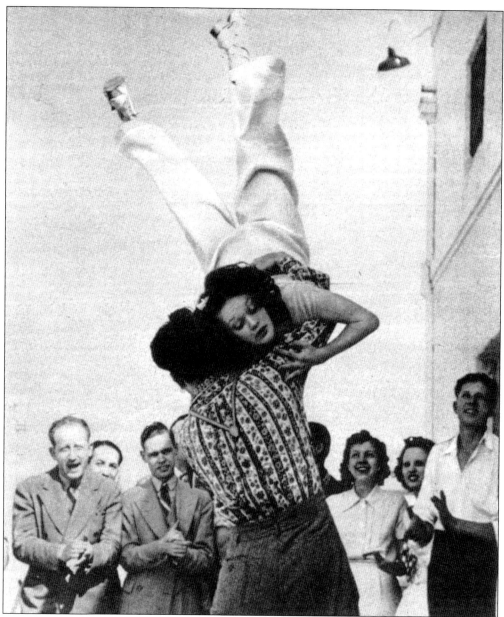

At 8:00 a.m., the music stopped, but the dancing continued out on the boardwalk in front of the Rendezvous. Here a couple performs the "Flying Dutchman." (Delaney collection.)

In 1940, residents were asked to vote on a measure that would prohibit dancing in public dance halls, cafés, restaurants, dining rooms, and other public places after midnight. In this advertisement placed in the *Balboa Times*, the management of the Rendezvous Ballroom makes a case for staying open until 1:00 a.m. on Saturday evenings only. (Delaney collection.)

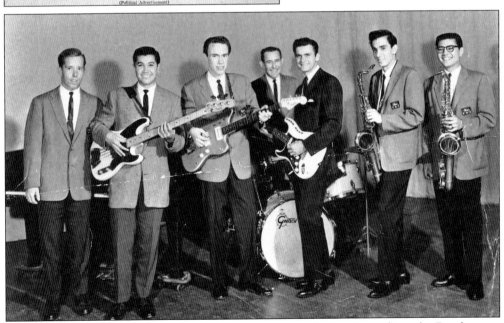

In the early 1960s, Dick Dale and the Del Tones brought the "surf sound" to the Rendezvous. Four decades later, Dick was back, entertaining the crowds in Peninsula Park at Newport's "Pier to Pier" centennial celebration. (Newport Beach Centennial Collection.)

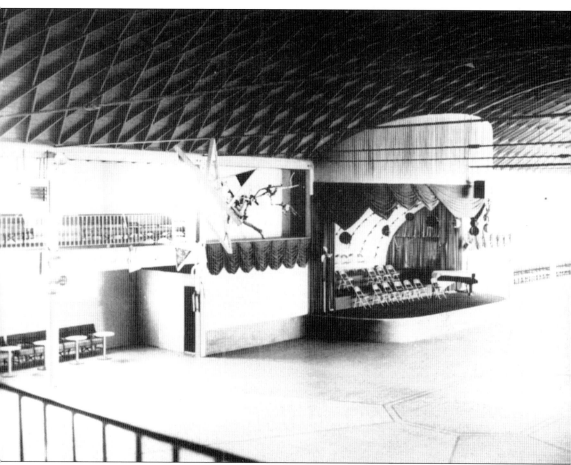

This is the interior of the glorious Rendezvous Ballroom, "The Place" to be for the Bal Week crowds, the swing dancers, and the legions of servicemen who flocked here on weekend leaves from the nearby Santa Ana Air Base. (Hugh McMillan.)

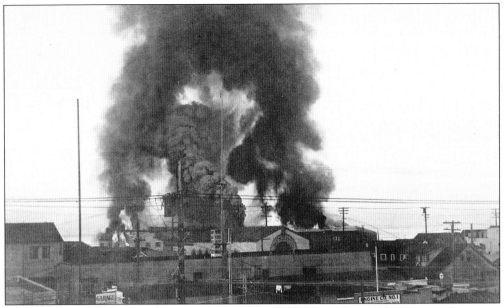

The Rendezvous burned to the ground on August 7, 1966. At about 4:00 a.m., a soft, orange glow could be seen through the block-long building's windows. The orange slowly turned to red, smoke filled the place, the roof caved in, and flames shot high into the sky. There would be no rebuilding this time. (Hugh McMillan.)

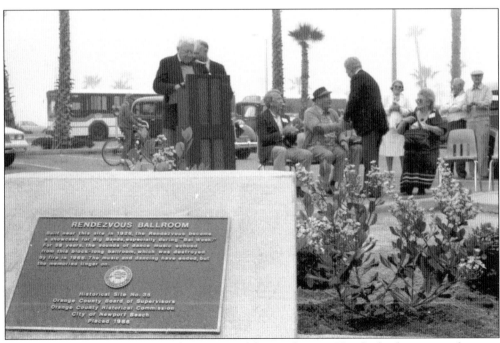

In 1986, a plaque was dedicated to the memory of the Rendezvous. Hundreds of young people pass it every day on bicycles or on foot, not even noticing it. But occasionally, a member of the older crowd will pause, then look up at the condominiums that now stand where the Rendezvous once stood, and maybe the memories they recall add a little spring to their step. (Orange County Archives.)

Three

THE BEACH AND THE BAY

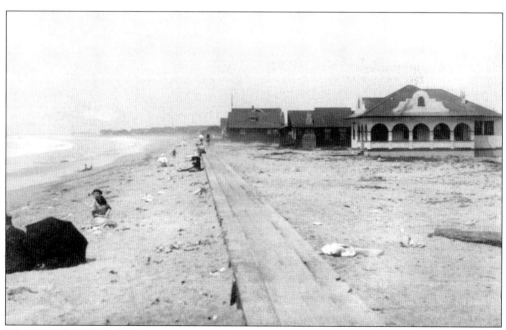

The oceanfront boardwalk was constructed in 1917 and 1918. It was the promenade connecting the villages of Balboa and Newport. In 1936, a concrete sidewalk replaced the deteriorating wooden boards. (Delaney collection.)

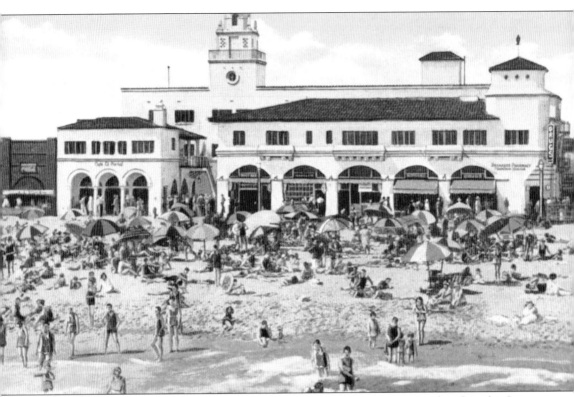

The Balboa Inn, constructed west of the Balboa Pier in 1929, was the finest hotel on the Orange County coast and the favored spot for movie stars and dignitaries. Visible on the first floor of the hotel is the Breakers Pharmacy, known as the "drugless drugstore" because customers would have struggled to find so much as an aspirin on its shelves. But for 25¢, the druggist would dispense an ounce of straight grain alcohol, the liquor of choice in Balboa. Hard to get down and keep down, customers often mixed the alcohol with ginger ale or grapefruit juice. (Delaney collection.)

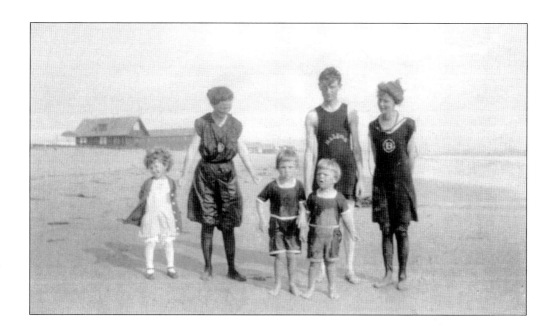

The beach at Balboa is seen here in 1914 (above) and 1919 (below). Swimmers in the early years had to proceed cautiously because Balboa could not afford to maintain a corps of paid lifeguards. (Above, Delaney collection; below, Newport Harbor Nautical Museum Archive.)

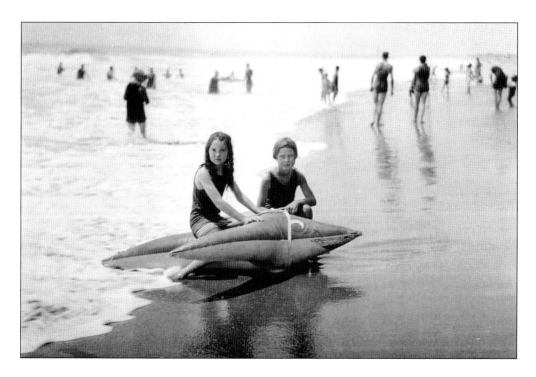

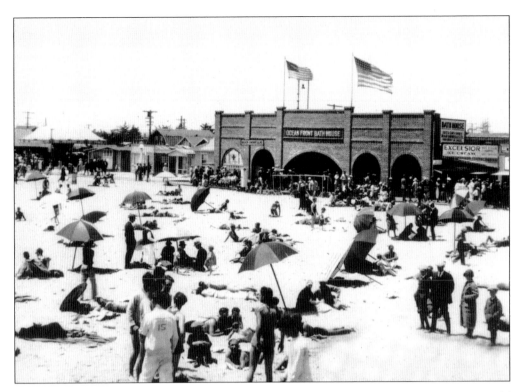

The Ocean Front Bath House was built by E. H. Rose in the summer of 1916. In 1919, Rose sold the business to Ray G. Burlingame, L. L. Garrigues, and H. B. Tudor, who had formed the Balboa Beach Amusement Company. Visitors arrived in Balboa on the Pacific Electric in their street clothes and then rented a bathing suit at the bathhouse. Suits came in three sizes, small, medium, and large. (Above, First American Corporation Archive; below, Delaney collection.)

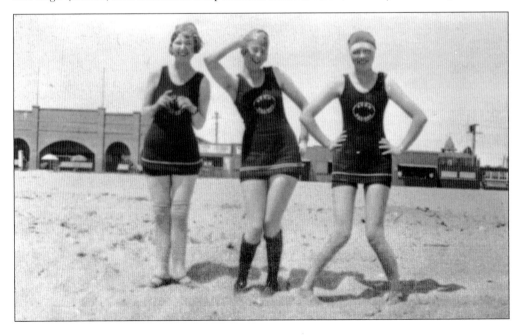

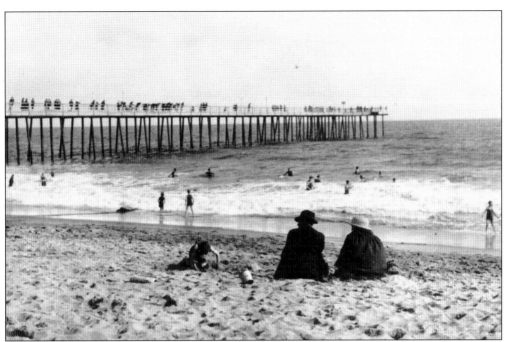

Novice bathers could take advantage of a safety line (left), a rope leading into the water from the beach. (Delaney collection.)

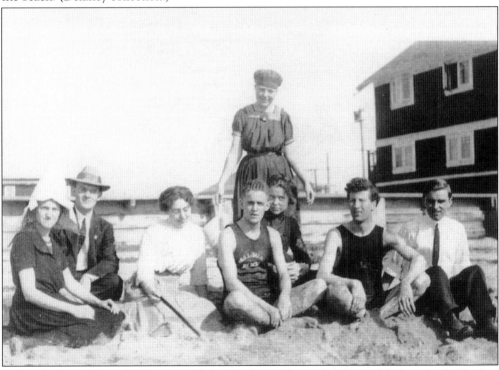

In this photograph from 1913, a group of visitors relax on the sand in front of the boardwalk. Vendors with carts carrying cold drinks and snacks would set up along the boardwalk, and children would try to retrieve coins dropped between its wooden planks. (First American Corporation Archive.)

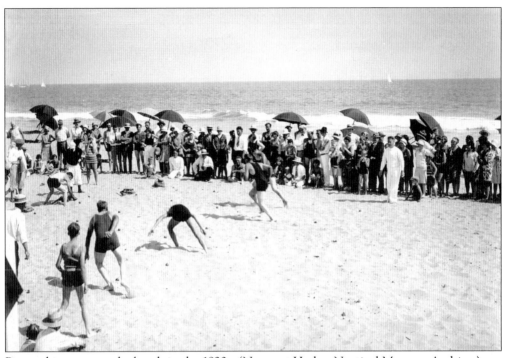

Pictured is a race on the beach in the 1920s. (Newport Harbor Nautical Museum Archive.)

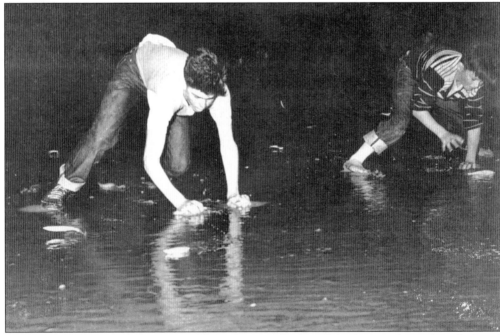

The grunion are running! California grunion are small silvery fish, 5 to 6 inches in length, found only along the coast of Southern California and Northern Baja, who come ashore to spawn just after high tide, sometimes literally covering sections of the beach. Grunion runs offer a unique sight of crowds of people lining the beach at 3:00 a.m., gunnysacks and flashlights in hand, trying to grab the slippery fish before the next wave comes in. (Hugh McMillan.)

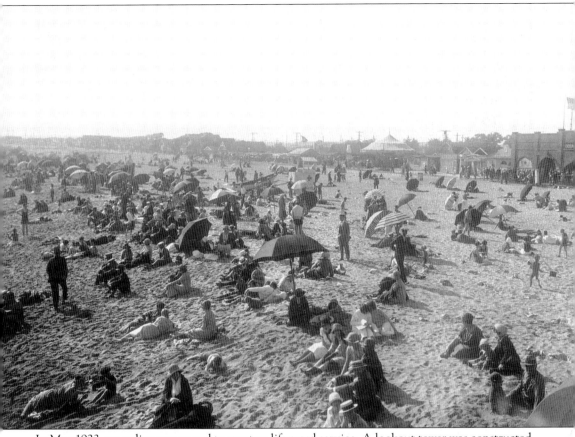

In May 1923, an ordinance passed to create a lifeguard service. A lookout tower was constructed in front of the Ocean Front Bath House, and for two years, a small emergency hospital room was maintained in the building. Also present in this 1923 photograph is what appears to be a merry-go-round just beyond the boardwalk. (Newport Harbor Nautical Museum Archive.)

Mercedes Vale, who resided in Corona del Mar, takes her ease on the beach at Balboa in 1929. (John Vale collection.)

Marguerite and Pamela Whitford are seen here kite flying east of the Balboa Pier in 1947. (Brigandi collection.)

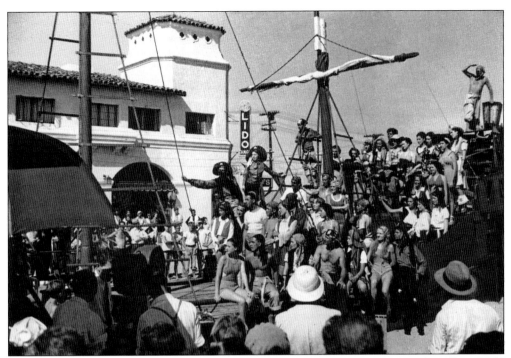

Pirate Days was an annual event dreamed up by Balboa merchants to promote the village. Held for only a few years, the event became a headache for police when participants got a bit carried away in their pirate roles. (Newport Harbor Nautical Museum Archive.)

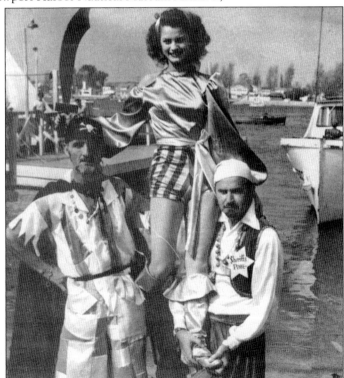

A sheriff's posse takes a rather appealing pirate into custody. (Hugh McMillan.)

The village's first landmark was the Balboa Pavilion. When it was built in 1905, it stood out like a skyscraper on the barren sand spit. This photograph shows the sparse settlement around the Pavilion soon after its completion. (Delaney collection.)

This is a 1915 view of a mother and child out for a stroll on the bay-side boardwalk, which no longer exists east of the Pavilion. (Delaney collection.)

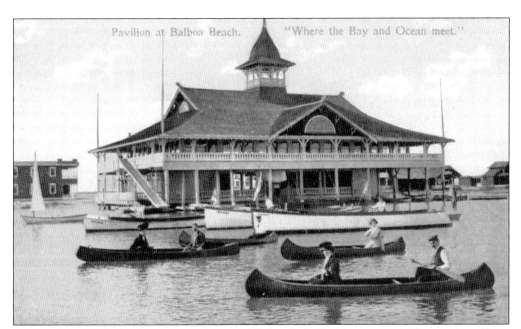

In its early years, the harbor was treacherous, filled with shallow lagoons, mudflats, and sandbars. The shallow draft of a canoe made it a safe mode of transport. This photograph is from 1911. (Delaney collection.)

Joe Ferguson, left, son of the original owner of Peninsula Point, is shown here with his collection of toy boats and an unidentified friend. Young Joe demonstrated his appreciation for another mode of transportation at the age of seven when he climbed aboard an empty Pacific Electric Red Car and operated it solo from Balboa to Newport. Bystanders looked on in horror as the car gained speed, but little Joe managed to bring it to a stop before any harm was done. (First American Corporation Archive.)

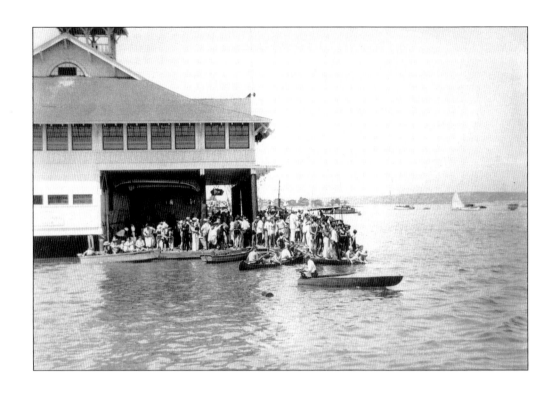

By 1911, the harbor was home to some 200 rowboats and canoes. Above, crowds gather at the Pavilion, waiting for their turn to tour the harbor. (Both photographs Newport Harbor Nautical Museum Archive.)

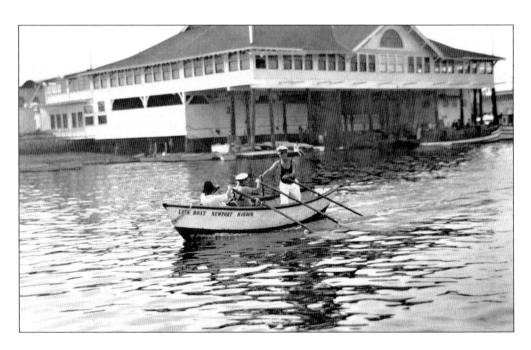

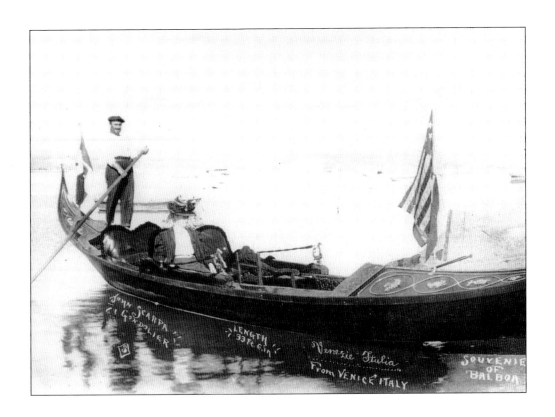

In 1908, gondolier John Scarpa moved his gondoliering business from Venice, California, to Newport Bay. For several years, he conducted a successful business, taking visitors around the harbor while serenading them in true Venetian style. (Both photographs First American Corporation Archive.)

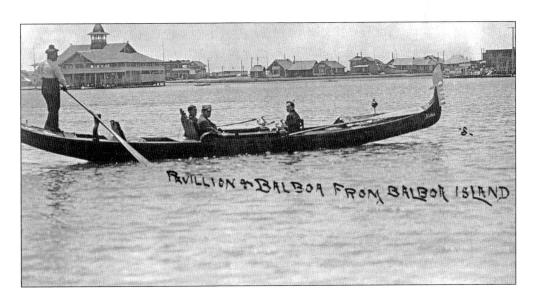

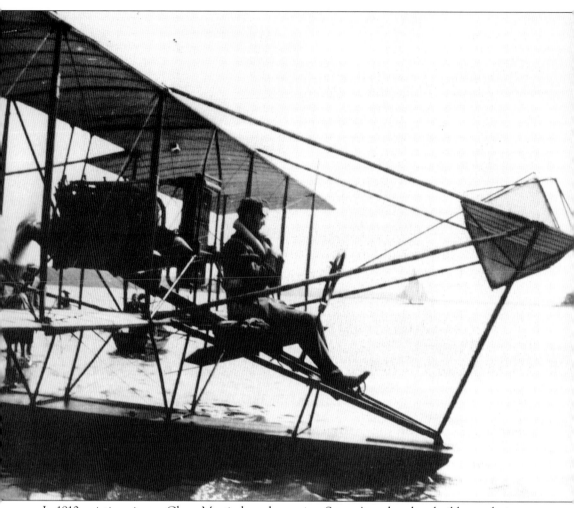

In 1910, aviation pioneer Glenn Martin leased space in a Santa Ana church to build a revolutionary new aero-hydroplane. On May 10, 1912, Martin flew his creation from the bay in Balboa to Catalina and back. The flight took 37 minutes and was the longest, fastest, over-water flight ever recorded at that time. He even brought the day's mail back from Catalina. (First American Corporation Archive.)

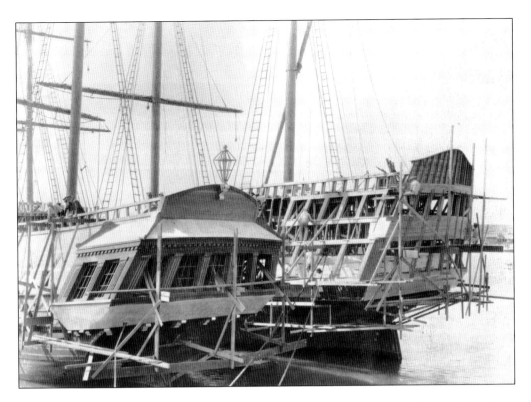

In 1924, two old sailing ships, the *Prosper* and the *Taurus*, were converted from schooners to pirate ships at shipyards west of the Pavilion for the epic silent film *Captain Blood*. During the filming, both ships were sunk off the coast of Catalina Island. (Both photographs First American Corporation Archive.)

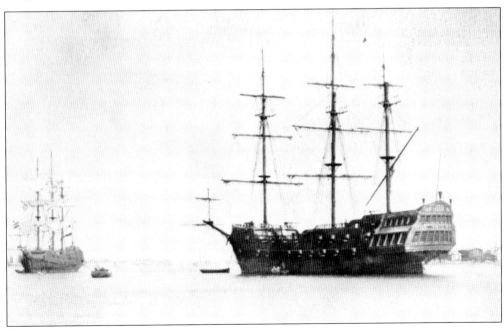

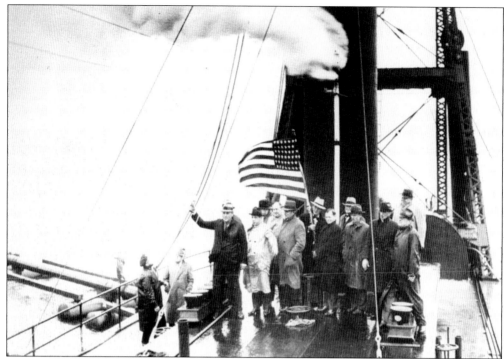

Civic leaders break a bottle of champagne to celebrate the beginning of massive harbor improvements. George Rogers, whose son had lost his life at the treacherous harbor entrance, read of the New Deal's National Recovery Act and set off for Washington, D.C., with city engineer Richard L. Patterson in tow. The pair won the endorsement of the U.S. Army Corps of Engineers and federal funding for all but $640,000 of a $1,839,000 project. (Sherman Library.)

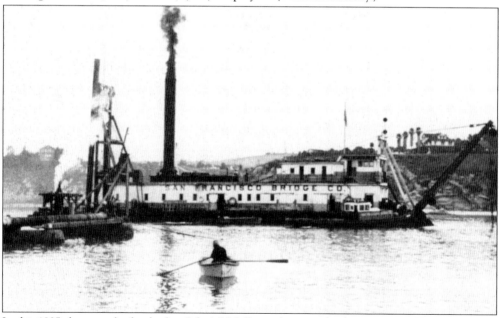

In this 1935 photograph, the dredger *John McMullen* sucks away the dangerous sandbars and pumps the sand and silt through a giant pipe to the Balboa shoreline. (Hugh McMillan.)

Early civic leaders Harry Welch (left) and Dr. Albert Soiland are seen during Harbor Day festivities in 1936. Welch was the secretary of the chamber of commerce and was instrumental in the passing of the county-wide bond issue that raised the remaining $640,000 needed for the harbor improvements, a remarkable accomplishment at the height of the Great Depression. Dr. Soiland was the founder and first commodore of the Newport Harbor Yacht Club. (Sherman Library.)

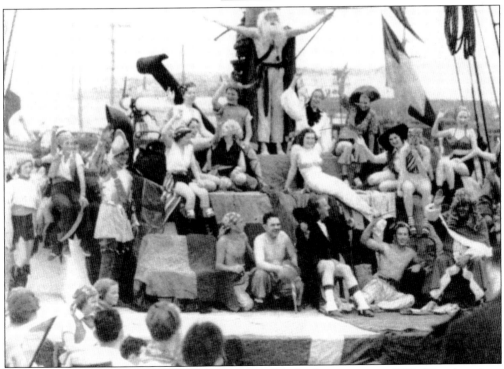

Pirates and Father Neptune observe the dedication of the harbor opening in 1936. (First American Corporation Archive.)

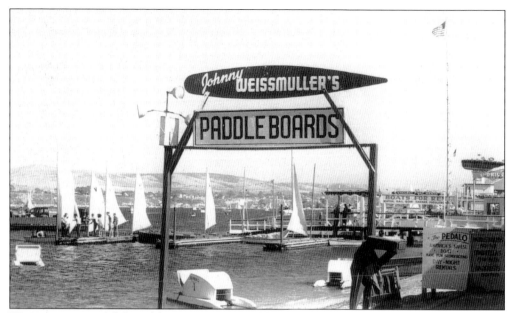

Want to rent a paddleboard from Tarzan? It could be done in Balboa Bay. Johnny Weissmuller, the most famous portrayer of Tarzan, was also a resident. The U-Drive sign, barely visible on the far right, has been restored and is now displayed at the ferry entrance. (First American Corporation Archive.)

A swordfish is unloaded for weighing at the Balboa Angling Club's dock at A Street next to the Pavilion. (Hugh McMillan.)

Three marlins were caught on September 28, 1946, by fishermen aboard the boat *Alamo*, skippered by Wes Fowler. (Hugh McMillan.)

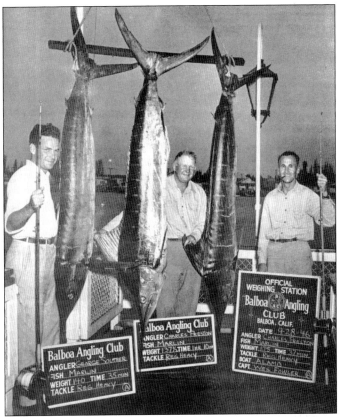

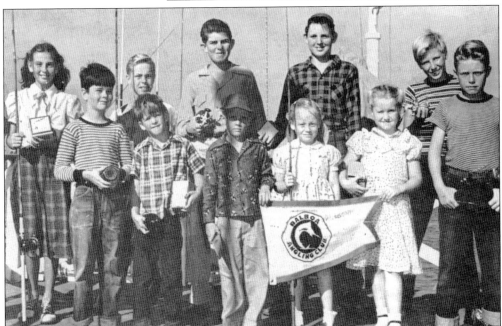

The Balboa Angling Club's junior fishing tournament winners are shown in this group photograph from the 1940s. (Hugh McMillan.)

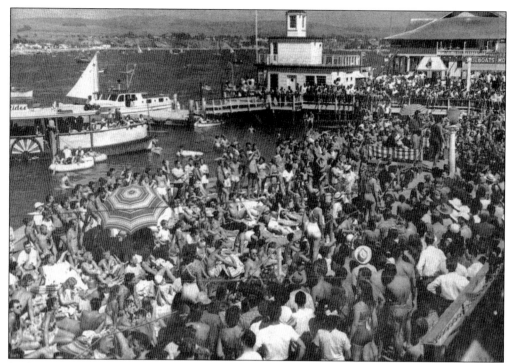

In the 1950s, Al Anderson revived the bathing beauty contest that had been so popular in Balboa in the 1920s. (Hugh McMillan.)

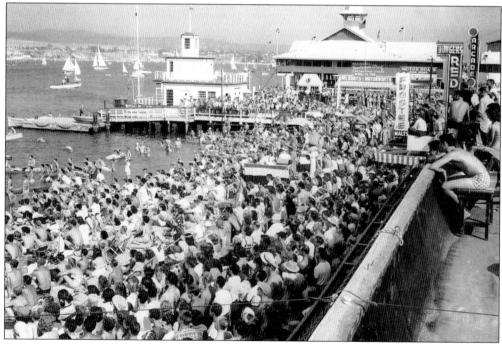

As was the case with Bal Week, promotional events that drew massive crowds to Balboa resulted in complaints from an ever-increasing number of residents. For better or worse, these events no longer take place. (Sherman Library.)

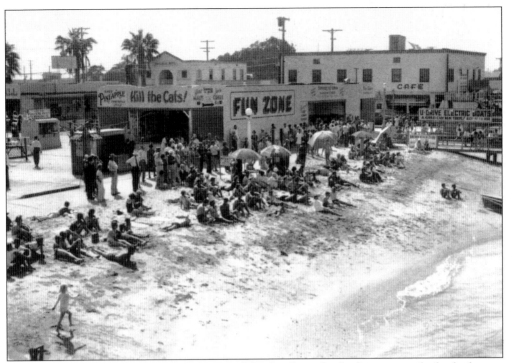

This image shows the bay-side beach west of the Pavilion. Sunbathers in need of refreshment could partake of sliced pineapple, ice cream malts or cones, sandwiches, and popcorn from the Fun Zone's many vendors. (First American Corporation Archive.)

The Grey Goose was located on the bay on the corner of Adams and Edgewater Avenue. During its heyday in the 1930s and 1940s, it was owned by Bo Roos. Roos also owned a management company in Hollywood that represented, among others, Fred MacMurray. There were always available rooms for the likes of MacMurray, Humphrey Bogart, or Johnny Weissmuller at the Grey Goose. (First American Corporation Archive.)

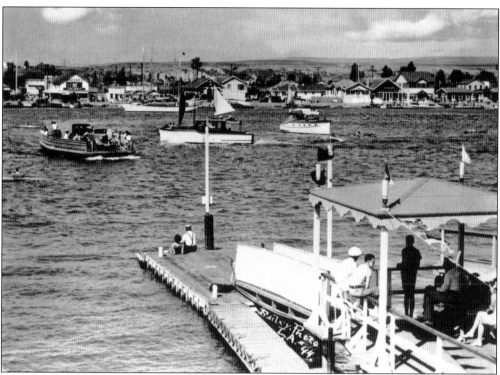

Tourists on their way to the island wait anxiously for the ferry's arrival. (First American Corporation Archive.)

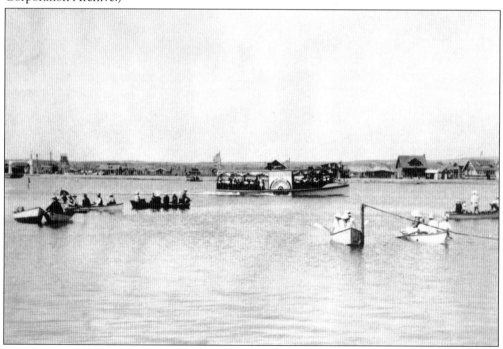

A large group enjoys a tour of the harbor while the more adventurous rent canoes and chart their own course. (First American Corporation Archive.)

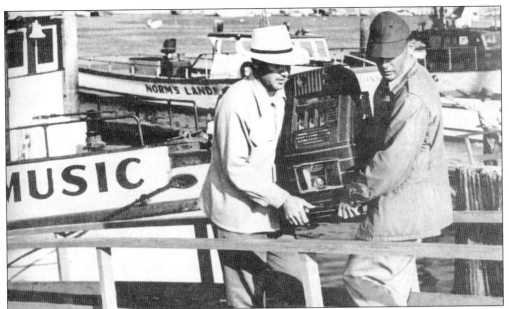

Based on a tip that gambling was taking place on area fishing vessels, the FBI conducted an undercover raid that netted several one-armed bandits, like this one pictured being hauled off the *Music*. Startled messages between fishing boats resulted in several slot machines being thrown overboard before the agents could find them. (Hugh McMillan.)

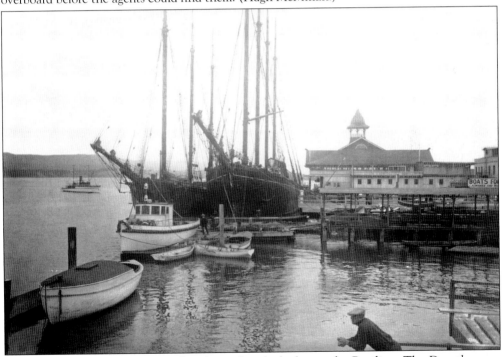

The four-masted schooner *Dauntless* (center) is docked near the Pavilion. The *Dauntless* was built in 1898, was 162 feet long, 37 feet wide, and weighed in at 548 tons. She was blown up on October 3, 1928, during filming of the Ronal Coleman 1929 motion picture *The Rescue* in Cat Harbor on Catalina Island. (Newport Harbor Nautical Museum Archive.)

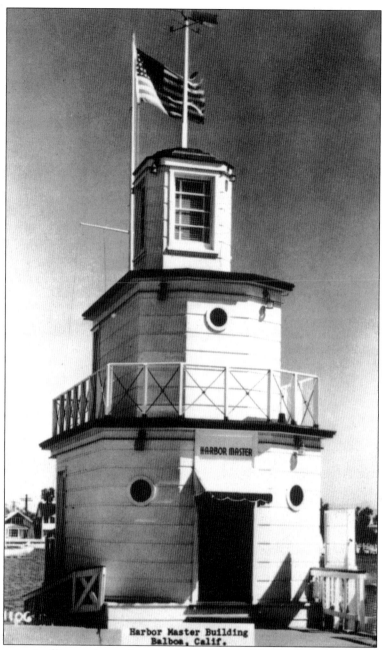

Harbor Master Building
Balboa, Calif.

The harbormaster's office was located on the city dock west of the Pavilion. The harbormaster had many duties, including the return of rowboats each morning. Since the ferry stopped operating at midnight, folks who found themselves on the wrong side of the bay would find the nearest rowboat and take it across. The next morning the harbormaster cruised down the bay front and towed the rowboats back to the proper side. In the 1920s, rumrunners unloaded their illegal liquor at the city dock. A long line of black sedans would pull to the curb on Washington Street and wait for the speedboats to arrive. A rough looking bunch would disembark and unload the cases of booze, and the drivers of the sedans would load up their cars and head up to Los Angeles. (First American Corporation Archive.)

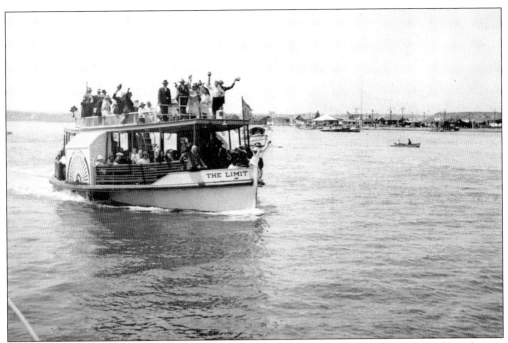

An enthusiastic tour group is depicted here aboard *The Limit*. (Orange County Archives.)

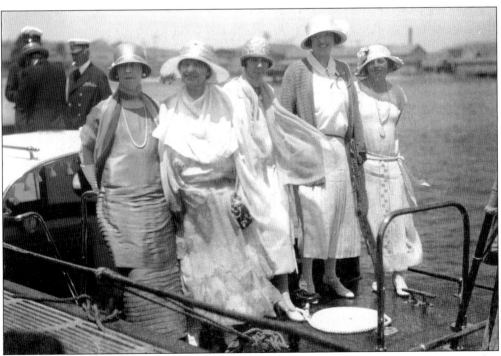

The commodores' wives pose for the camera while the commodores retreat for a smoke. (Newport Harbor Nautical Museum Archive.)

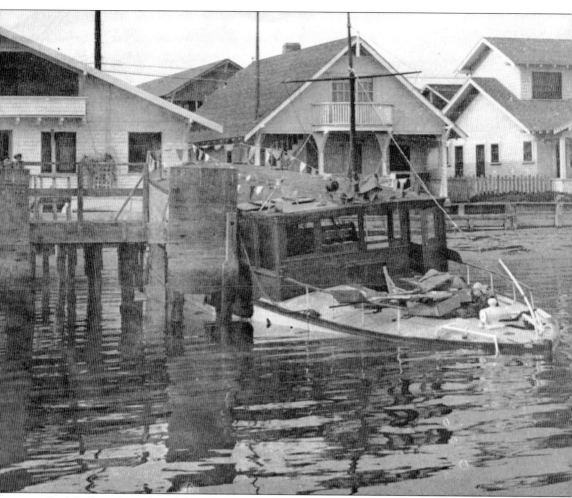

Bud Gollum, 21, and Beulah Overell, 17, were acquitted on charges of bludgeoning her parents to death and then trying to cover up the crime by blowing up the family yacht, the *Mary E.*, which was moored in the channel off the Pavilion one night in 1947. The sunken vessel is shown here, tied to a dock. In Orange County, the Overell case is still considered one of the most significant cases of the 20th century. (Hugh McMillan.)

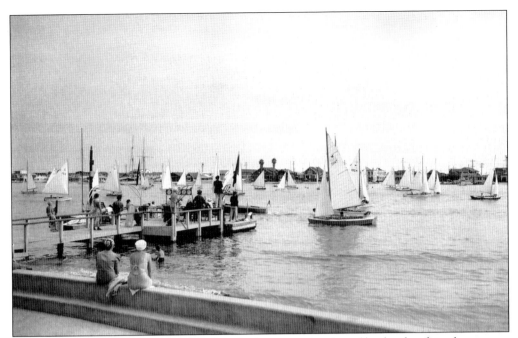

Begun in 1935, the annual Flight of the Snowbirds race was conducted by the chamber of commerce for boys and girls to stimulate interest in sailing among the youth of Newport Beach. It was so named because of the resemblance of more than 100 sails to a flock of migrating snowbirds. (Newport Harbor Nautical Museum Archive.)

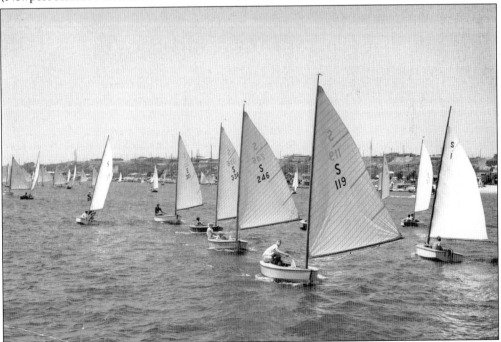

The first 10 skippers to finish the race received awards, as did the youngest boy and girl. In 1948, one hundred forty-eight craft entered the race, and all but eight finished the course. (Orange County Archives.)

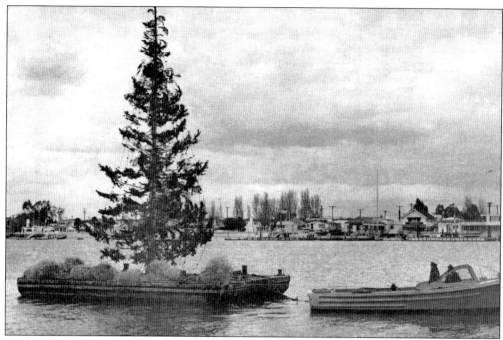

Nothing rings in the holidays better than the first floating Christmas tree on the bay, as shown in this 1940s photograph. (Hugh McMillan.)

The Festival of Lights was born on August 23, 1908, when Balboa's gondolier, John Scarpa, staged a small, illuminated parade with eight canoes and Scarpa's gondola, all lit by Japanese lanterns. In the 1920s, the parade was directed by Joe Beek, who called it the Tournament of Lights. Today the event takes place during the Christmas season and is a favorite holiday event for all of Orange County. (Newport Harbor Nautical Museum Archive.)

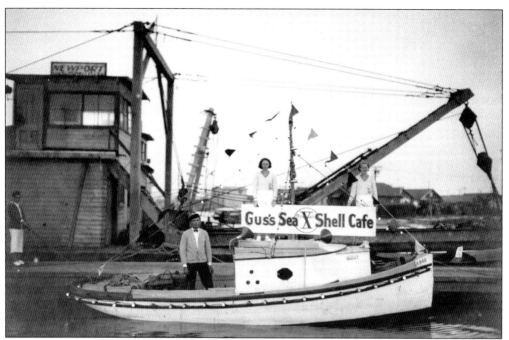

Gus Tamplis's Sea Shell Café, a popular café and bar, was located on the corner of Palm Street and Central Avenue across the alley from the Rendezvous Ballroom. Tamplis, born in Greece in 1893, came to America in 1907. The café building still stands, now operated as a bike rental shop. The boat pictured is decorated for the 1932 Summer Olympics held in Los Angeles. (First American Corporation Archives.)

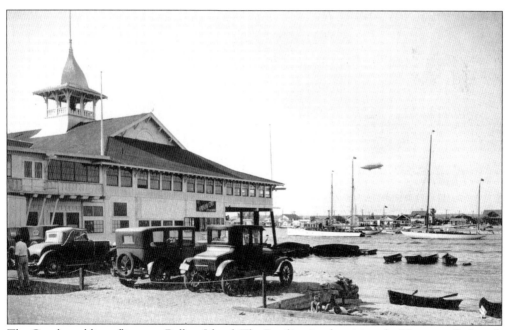

The Goodyear blimp flies over Balboa Island. The Pavilion is advertising the Hawaiian Café with the tagline "Let's Go Native." (Newport Harbor Nautical Museum Archive.)

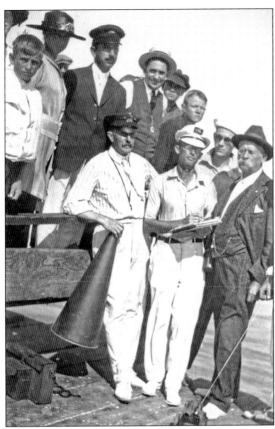

Scoring a boat race is the job of serious men in possession of a diminutive cannon and a large bullhorn. (Both photographs Newport Harbor Nautical Museum Archive.)

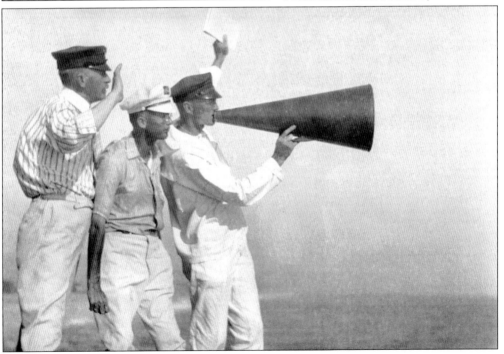

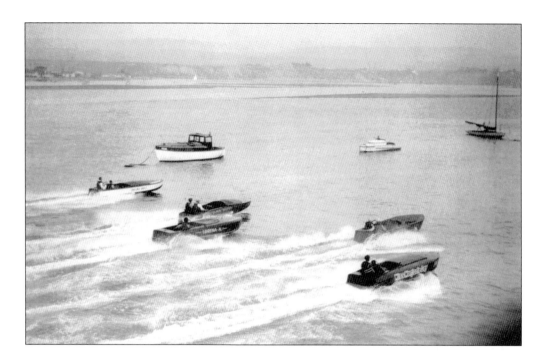

Prior to the late 1930s, there was no speed limit in the bay, allowing boats like the *Miss Marjorie Gay*, *Baby Mine*, *Quick Silver*, and *Smiling Dan II* to race in the harbor. To prevent collisions, sirens would sound to warn swimmers and boaters. Today the speed limit in the harbor is five miles per hour. (Both photographs Newport Harbor Nautical Museum Archive.)

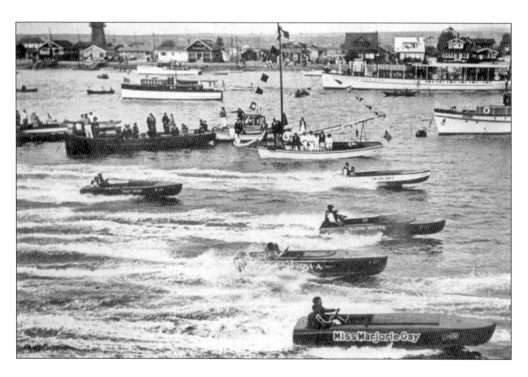

The bay-side beach is gone now, taking with it the ability to buy a taco, a frozen treat, or a box of sweets on a summer day by the sea. (Orange County Archives.)

Four

TAKE THE FERRY
TO THE ISLAND

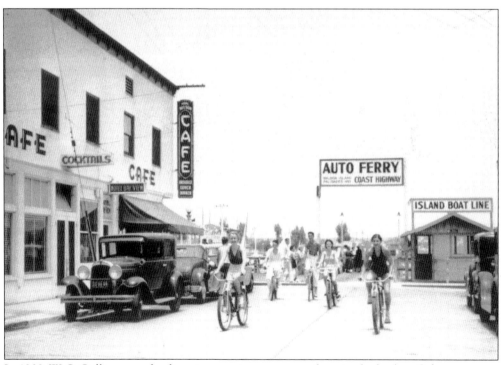

In 1909, W. S. Collins won the first city permit to operate a ferry in the harbor. Other operators followed, but the service was deemed unsatisfactory. Finally, in 1919, Joseph Beek won the contract to operate the Balboa-Balboa Island Ferry, a tradition the family continues to this day. This photograph is from 1932. (First American Corporation Archive.)

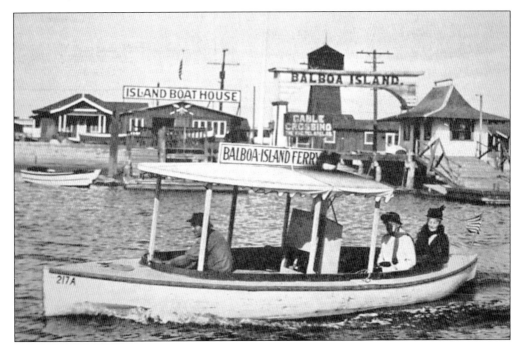

The earliest ferry, operated by W. S. Collins beginning in 1909, was called the *Teal*. Capt. John Watts piloted the boat and had a penchant for singing to his passengers. The single cylinder–engine vessel went out of service in 1917, and for a few years, island residents were never sure that passage across the bay would be available. Joe Beek's first ferry was a large rowboat with an outboard motor called the *Ark*. Pictured above and below is Beek's second ferry, the *Islander*, a wrecked, abandoned hull that Beek repaired in the Island Boathouse. (Both photographs Balboa Island Historical Society.)

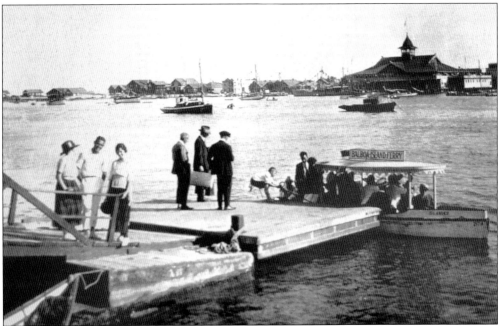

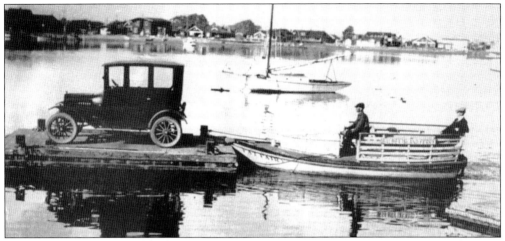

The *Fat Ferry* was built in 1920. It was 22 feet long, 8 feet wide, and carried 20 passengers. A year later, it was attached to a small barge and became the first ferry that could accommodate automobiles. (Balboa Island Historical Society.)

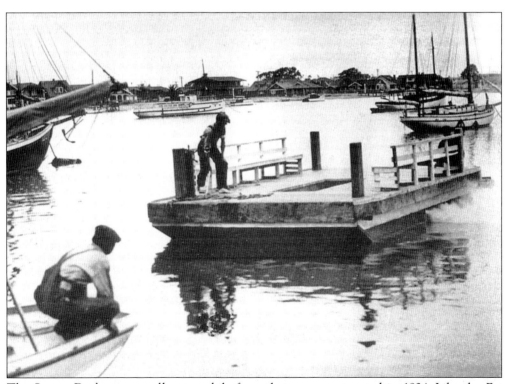

The *Square Deal* was a small automobile ferry that was constructed in 1924. Like the *Fat Ferry*, it only carried one car. This photograph is believed to be from 1924. (Balboa Island Historical Society.)

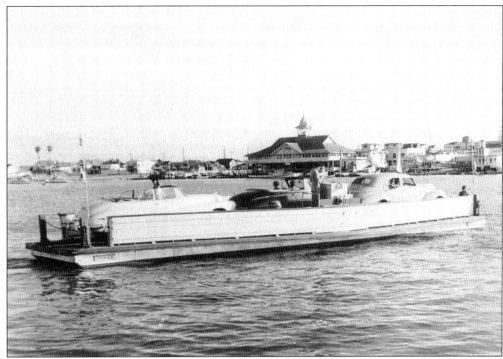

When the *Joker* (above) was originally built in 1922, it carried two cars, was 32 feet long, had a propeller at each end, and was steered by both rudders at once. In 1932, it was lengthened to match the 56-foot *Commodore* (below). (Both photographs Balboa Island Historical Society.)

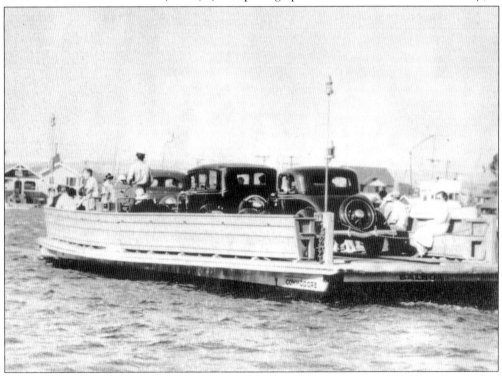

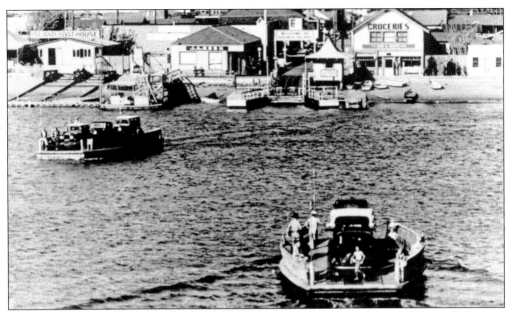

The *Joker* and the *Commodore* cross paths in the harbor in 1934. (Delaney collection.)

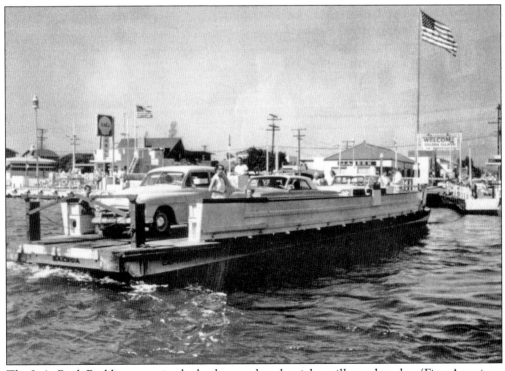

The J. A. Beek Building, seen in the background to the right, still stands today. (First American Corporation Archive.)

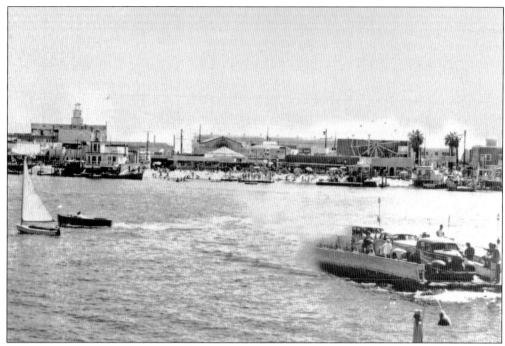

This view from the island looks toward the peninsula. The harbormaster's office is to the left of the Fun Zone. The expansive building in the distant background is the Rendezvous Ballroom. (First American Corporation Archive.)

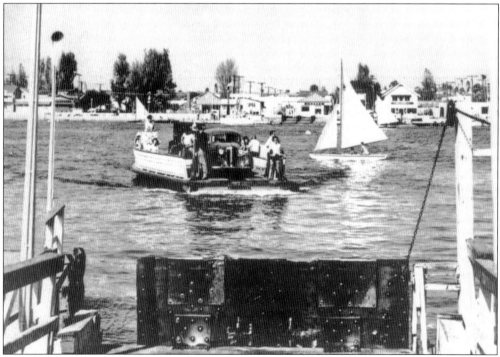

The *Joker* makes its approach. Today's ferries make as many as eight round-trips per hour. (First American Corporation Archive.)

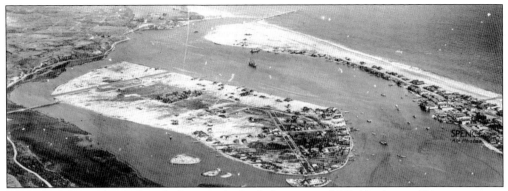

This aerial shot, taken before the bay was dredged, shows a sand-filled harbor and bare acreage on both Balboa Island and the peninsula. Back in 1906, W. S. Collins had commenced a dredging operation that was partially completed by 1910. Prior to that, the island was primarily swamp land and mostly underwater at high tide. (Delaney collection.)

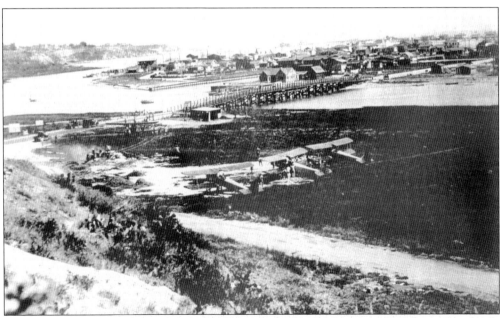

Airplanes are seen here tied down on an airstrip just across the bridge from the island. The island's original bridge was a 12-foot-wide wooden structure built in 1914. That was replaced by the wider bridge shown here, which stood from 1924 to 1928. (Hal Will and Mabel Smith.)

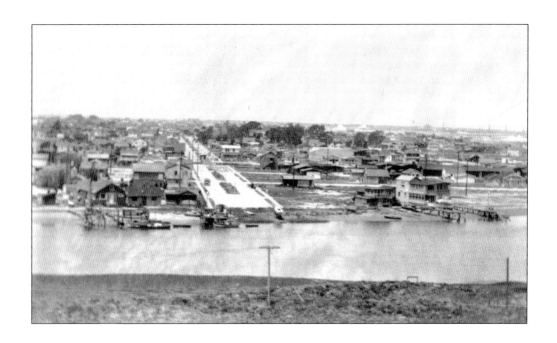

A new bridge was built in 1929. It was 400 feet long with 4-foot-wide sidewalks. (Above, Delaney collection; below, Balboa Island Historical Society.)

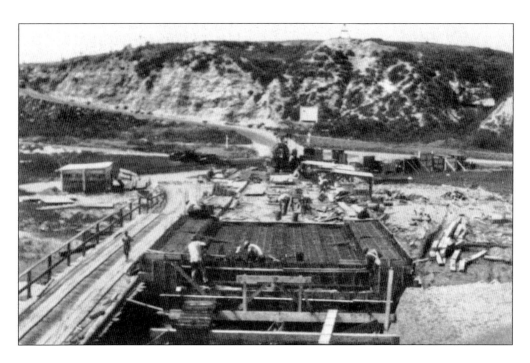

A newspaper advertisement advised people to buy a home now or pay more later because, "any person with good business judgment can see the future." (Delaney collection.)

Do You Want a Home on
BALBOA ISLAND

If so, you want to buy at once, as the number of lots is limited and if you wait another few weeks you will have to pay some one a profit, and then comes the old story—"Well, if I had bought a while back, I would have made 100 per cent on my investment." Be wise and get in now. Any person with good business judgment can see the future. They don't have to be told. Come with us on our next excursion and see for yourself. Seeing is believing.

LOTS $500 UP—Easy Terms

Balboa Island is in a class by itself. There is no other place on the whole Pacific Coast that is so limited and so exclusive as Balboa Island, surrounded by still salt water that affords the best boating, canoeing, motor-boating, yachting, fishing and swimming. Balboa Island has all modern improvements of an up-to-date city.

Next Excursion Today
(Thursday), August 1st

Round Trip Tickets, 50c
Including Lunch—Boat Ride Free

Get Your Tickets Now at This Office

BALBOA ISLAND REALTY CO.

303 Columbia Trust Building, 313 West Third Street
Pasadena Office: 72 North Raymond Avenue
Long Beach Office: 526 First National Bank Building

L. W. COFFEE, Manager ROY. K. WILSON, Asst. Manager

By 1914, seven hundred of Balboa Island's 1,300 lots had sold, $350 for inside lots and from $600 to $750 for those on the waterfront. The boom burst when promised improvements, including paved streets, sewers, streetlights, and a grand hotel, did not materialize. Property values dropped, and many were sold for taxes. (First American Corporation Archive.)

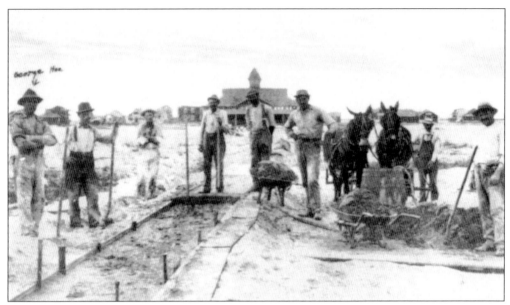

The first sidewalks on the island were laid down in 1914. (Wilfred Hoe.)

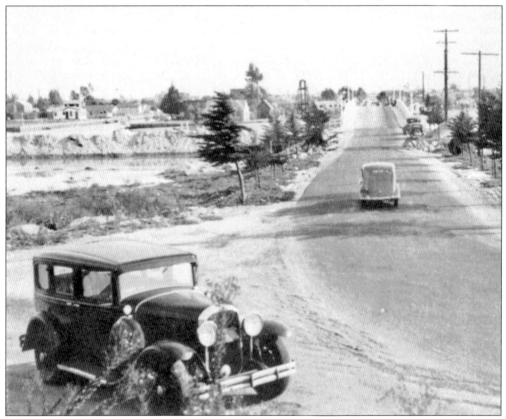

By 1935, trees had been planted leading to the bridge. The dike seen to the left of the bridge was part of the dredging and filling project being done throughout that year and the next. (Jim Sleeper.)

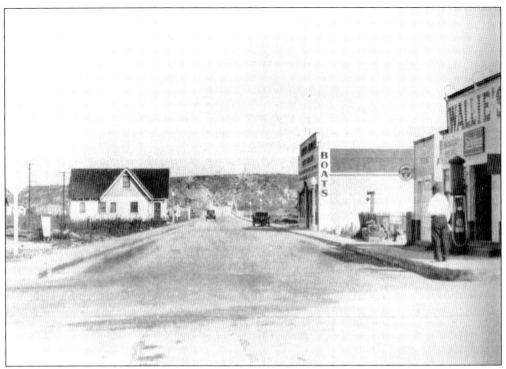

A 1928 view of the 200 and 300 blocks of Marine Avenue. The timbers lying in the field at the far left are from the old wooden bridge. Wallie's on the right is still a market today. (Hal Will and Mabel Smith.)

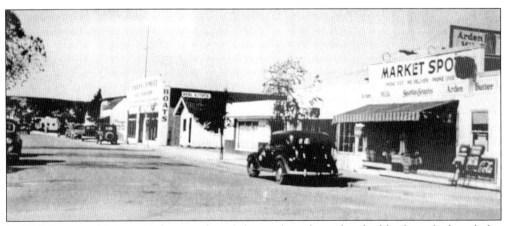

In 1935, Tony and Mina Hershey purchased the market where they had both worked as clerks, and it became the Market Spot. Today it is called Hershey's Market and Grog Shop. (Hal Will and Mabel Smith.)

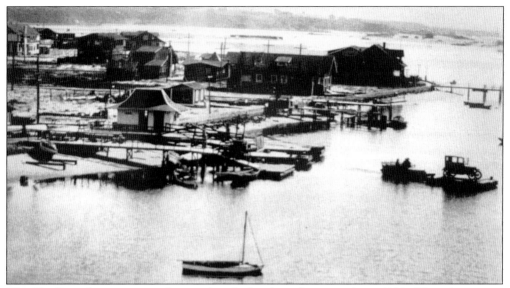

The *Fat Ferry* leaves a sparsely populated island in this view from 1921. (First American Corporation Archive.)

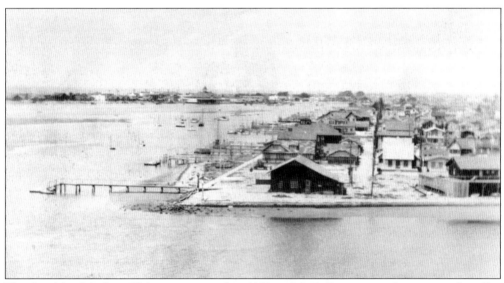

The Southland Sailing Club was organized in 1922 with I. B. Potter as its first commodore. For three years, the club met in various locations on the peninsula, until the spring of 1925 when a clubhouse was built on the corner of the island (pictured here). In 1928, the Southland Sailing Club changed its name to the Balboa Yacht Club. Throughout its existence, the club has done much to promote the sport of sailing. (Delaney collection.)

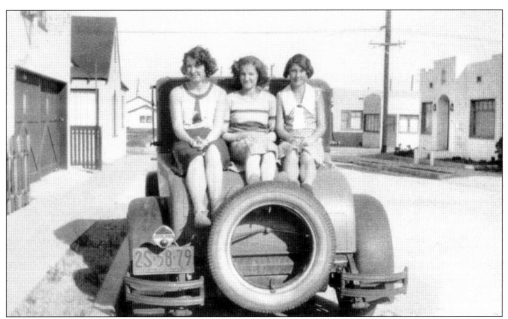

These three island girls look like they are ready to hit the road in this photograph dated April 1931. (Delaney collection.)

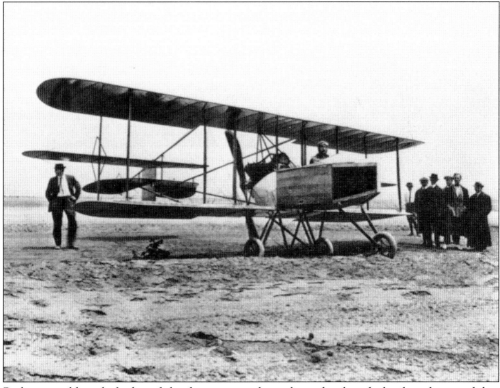

Biplanes could easily find a safe landing spot on the early, undeveloped island, as this one did in 1918. (First American Corporation Archive.)

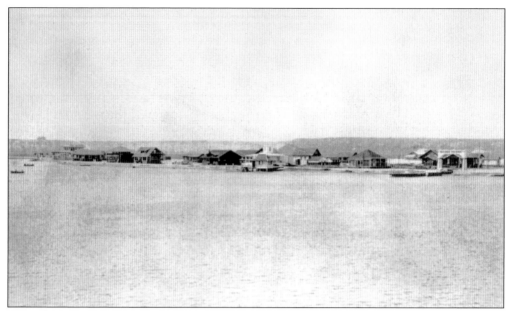

An early view of South Bayfront taken in the 1920s shows the ferry landing on the right. On the far left, Collins Island and Collins Castle, built for William S. Collins's fourth wife, Apolena, in 1907, are visible. James Cagney's brother, William Cagney, a producer and real estate magnate, owned the island for a time in the 1930s, and the U.S. Coast Guard set up an emergency center there immediately after the attack on Pearl Harbor. (First American Corporation Archive.)

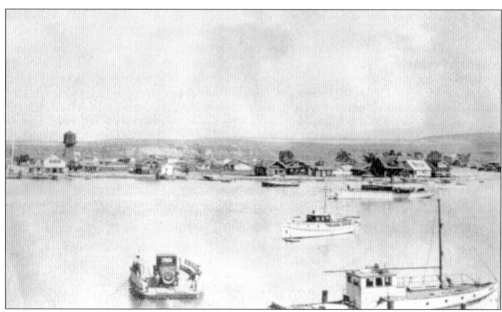

The large water tank on the left supplied fresh drinking water to the island. This photograph was taken in the 1920s. (First American Corporation Archive.)

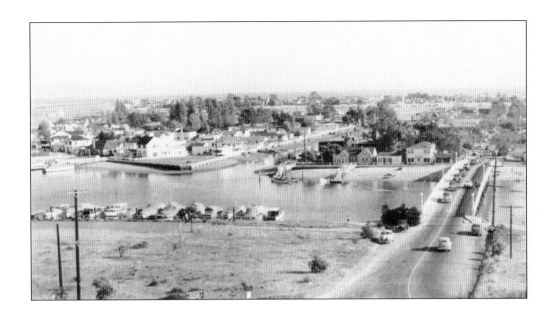

These are two views of the northern approach to the island, before and after the introduction of the service station. (Both photographs First American Corporation Archive.)

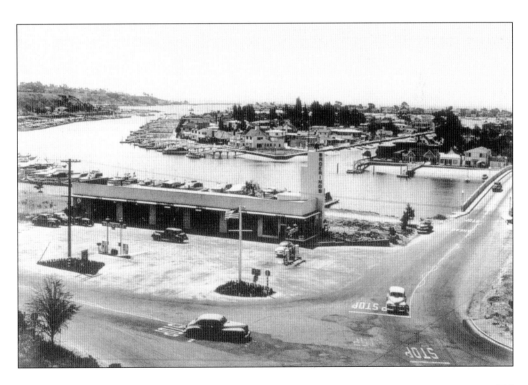

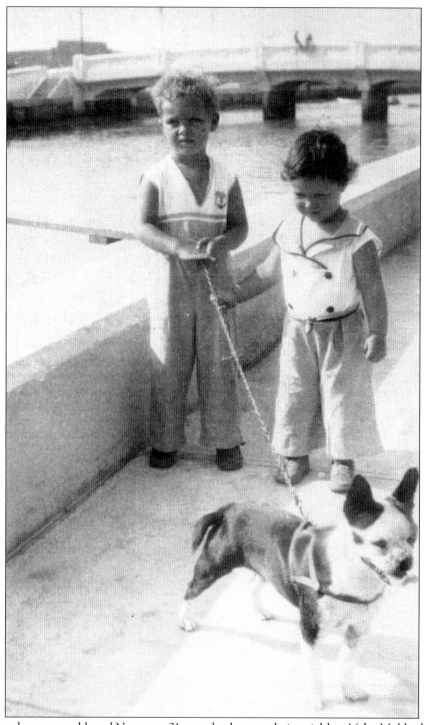

Harry, at three years old, and Nancy, at 21 months, borrow their neighbors' (the Moldenhauses) dog for a walk along the Grand Canal, sometime in the 1930s. (Delaney collection.)

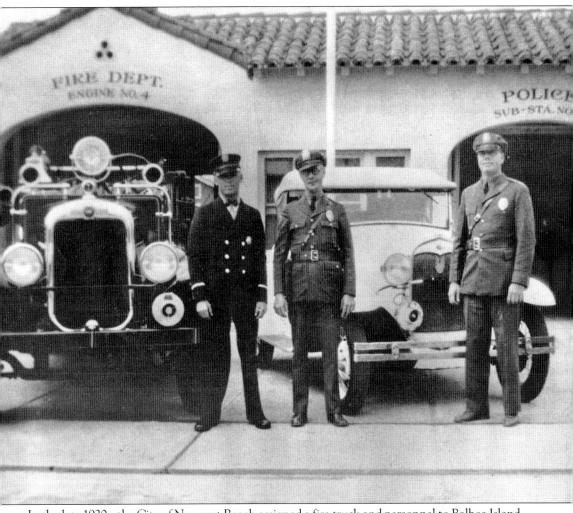

In the late 1920s, the City of Newport Beach assigned a fire truck and personnel to Balboa Island. The structure pictured was built, and for a time, the police shared the building as a substation. The current fire station is farther south on Marine Avenue, but this building still stands, now empty. (Balboa Island Historical Society.)

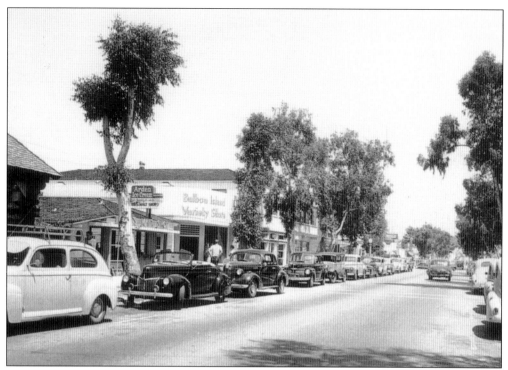
A thriving Marine Avenue is depicted in the 1940s. (First American Corporation Archive.)

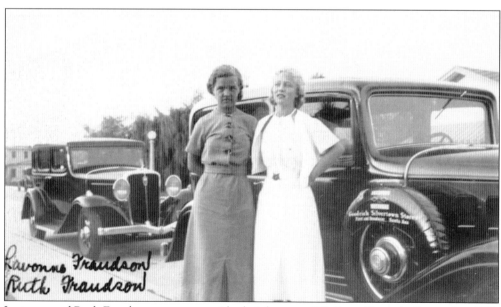
Lavonne and Ruth Fraudson are seen outside their home at 233 Onyx Street in September 1935. (Delaney collection.)

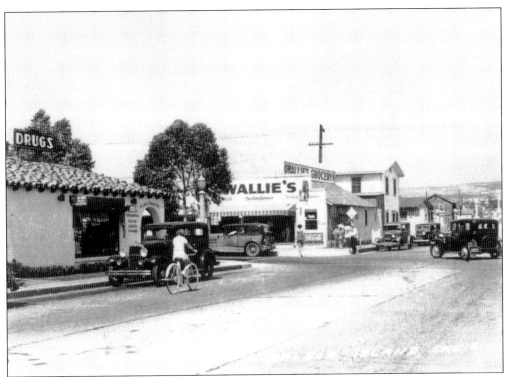

Allan's Pharmacy was always a popular spot for fountain service on a hot day like this one in 1935. (First American Corporation Archive.)

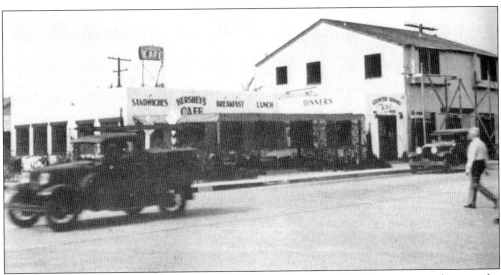

The southwest corner of Park and Marine Avenues has held a restaurant consistently since the early 1930s. The first was Hershey's Café, then a German beer garden, then White's Café and Bar, and finally the Village Inn, which is still in business today. (Hal Will and Mabel Smith.)

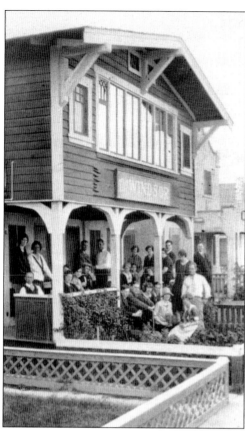

The Windsor looks like a pleasant place to stay while on the island. (Delaney collection.)

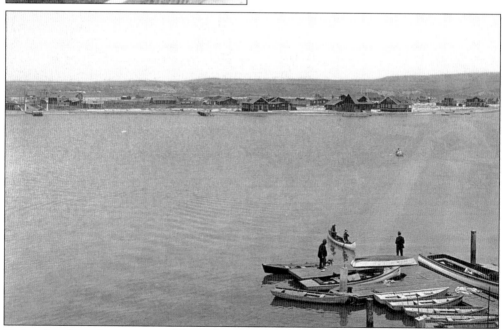

Only a few dozen houses are visible in this remarkable view of the island from 1915. (Orange County Archives.)

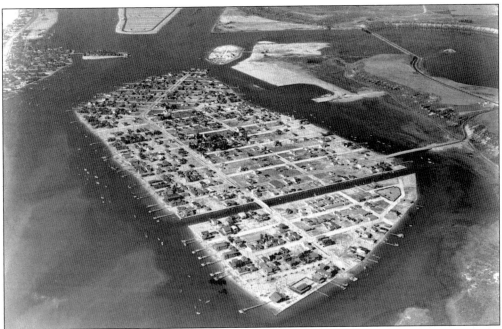

The Grand Canal between Balboa Island and the Little Island is 1,500 feet long and 100 feet wide. It was originally meant to be Moonstone Avenue, but W. S. Collins wanted to create a Monte Carlo–like resort on the Little Island with gondoliers transporting visitors across the Grand Canal. Concerned harbor boosters stopped Collins's resort idea, resulting in the island's unique configuration. (Balboa Island Historical Society Archive.)

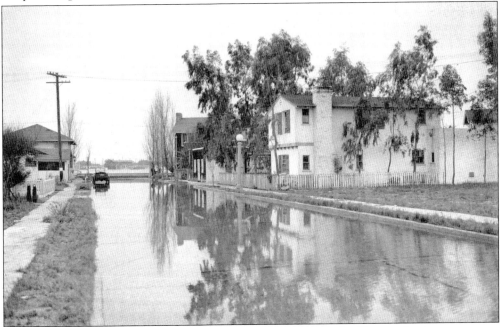

Floods in both 1928 and 1938 covered the streets with water. The building in the distance, across the bay on the peninsula, is the South Seas Club, which would later become Art LaShelle's Christian's Hut. (Balboa Island Historical Society.)

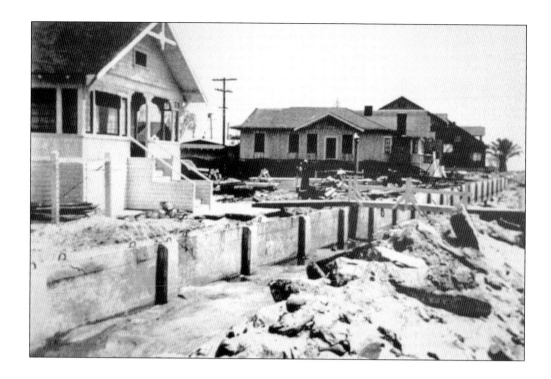

Long before the big dredge of the mid-1930s, W. S. Collins recognized the need for a seawall on the island. Starting in 1909, several attempts were made to build a wall, but harsh weather and poor materials and construction always led to failure. Finally, in 1938, federal funds available through the National Reclamation Act paid for the present seawall, an 8-foot-wide sidewalk, and five public piers. In the photograph below, the old cement chunks were removed before new cement was poured. (Both photographs Balboa Island Historical Society.)

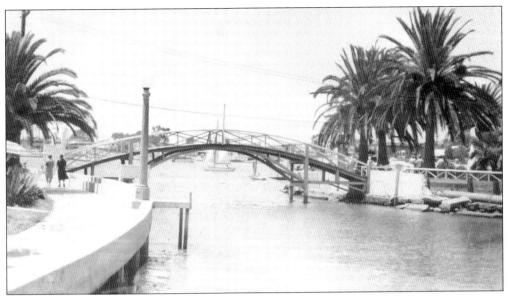

The bridge to Collins Island on the western tip of Balboa Island is seen here in 1942. (Delaney collection.)

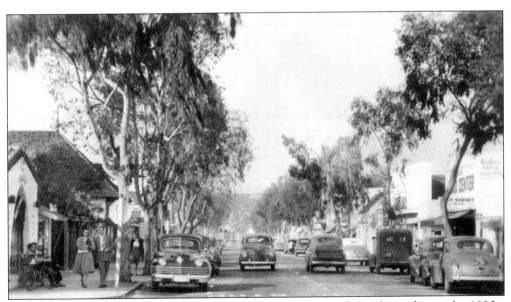

The eucalyptus trees that line Marine Avenue were planted in the early 1930s. (Delaney collection.)

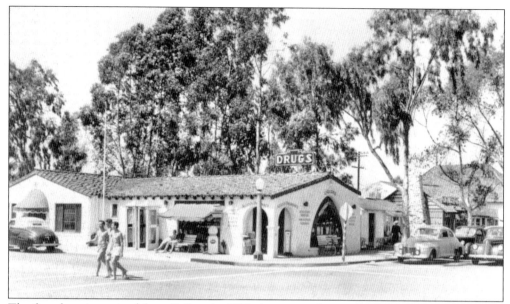

The first druggist arrived from Balboa in 1933. As soon as he set up shop, the March 12 Long Beach Earthquake hit, and all his just-shelved bottles came crashing to the ground. Luckily, a large drug company stepped in and helped him completely restock. (Delaney collection.)

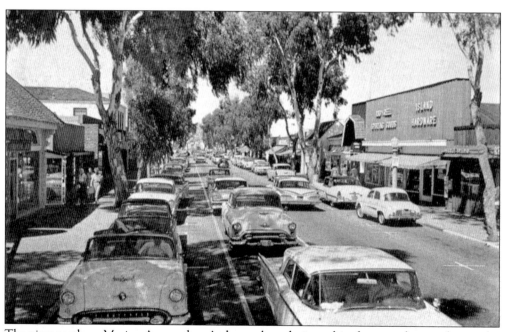

The view north on Marine Avenue hasn't changed much since this photograph was taken in the 1950s. (Balboa Island Historical Society.)

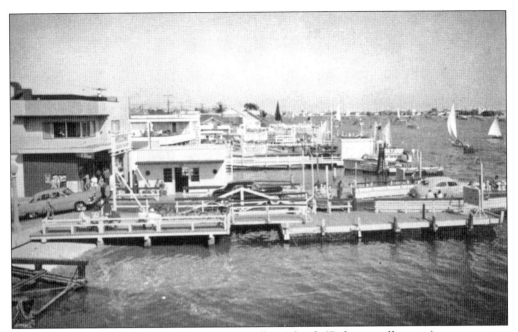

This 1958 photograph shows visitors leaving Balboa Island. (Delaney collection.)

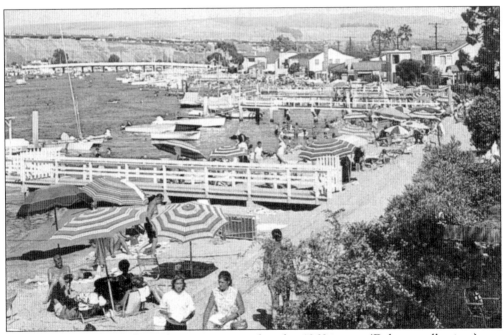

The promenade on North Bayfront was captured in this 1960 image. (Delaney collection.)

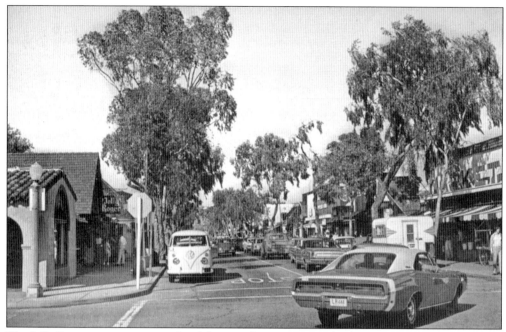

The Jolly Roger restaurant was a local favorite for many years. (Delaney collection.)

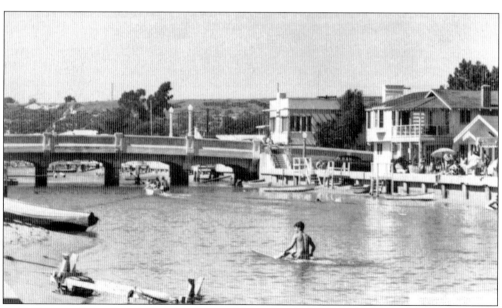

A 1948 view of the Grand Canal is depicted here. By the mid-1950s, the hills in the distance would be occupied by homes in Irvine Terrace.

Pictured from left to right in the 1930s are Norman Nelson, Nellie Nelson, and Jasper Vale. Vale frequently launched his canoe from the small beaches along North Bayfront. (John Vale collection.)

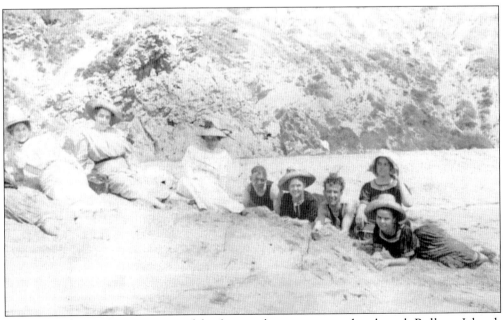

In the early 1910s, a group of bathers relax on an undeveloped Balboa Island. (Delaney collection.)

ACROSS AMERICA, PEOPLE ARE DISCOVERING SOMETHING WONDERFUL. THEIR HERITAGE.

Arcadia Publishing is the leading local history publisher in the United States. With more than 4,000 titles in print and hundreds of new titles released every year, Arcadia has extensive specialized experience chronicling the history of communities and celebrating America's hidden stories, bringing to life the people, places, and events from the past. To discover the history of other communities across the nation, please visit:

www.arcadiapublishing.com

Customized search tools allow you to find regional history books about the town where you grew up, the cities where your friends and family live, the town where your parents met, or even that retirement spot you've been dreaming about.